The Illustrated Guide to Ingtegrated Learning

The Illustrated Guide to Ingtegrated Learning

Julia Marshall

A Publication of The Poetry Box®

©2019 Julia Marshall
All rights reserved

Artwork by Julia Marshall
Editing & Book Design by Shawn Aveningo Sanders
Cover Design by Robert R. Sanders

Printed in the United States of America

No part of this book may be reproduced
in any manner whatsoever without written
permission from the author, except in the case
of brief quotations embodied in critical essays,
reviews and articles.

Library of Congress Control Number: 2019938585
ISBN-13: 978-1-948461-29-0

Published by The Poetry Box®, 2019
Portland, Oregon
www.ThePoetryBox.com
530.409.0721

Dedicated to:

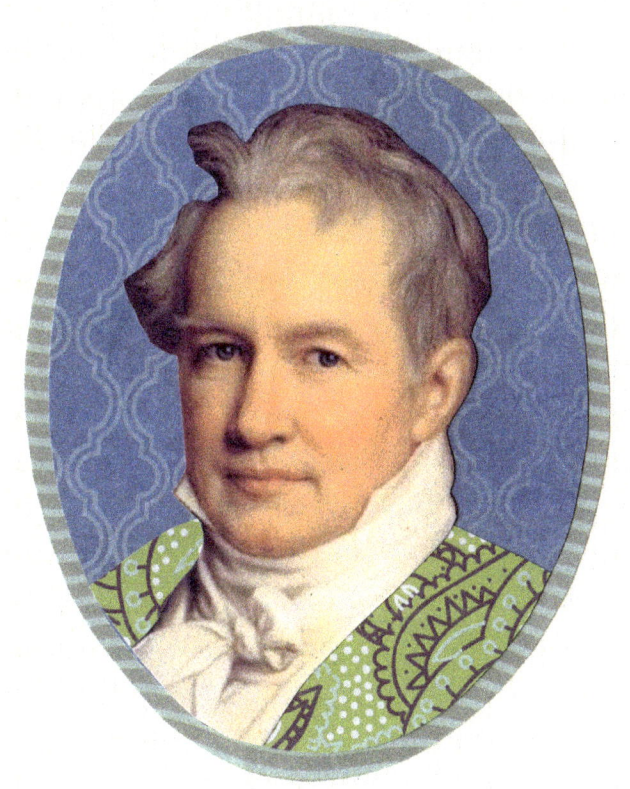

Alexander Von Humboldt
(1769-1859)
The Father of Info-Graphics and Ecology

TABLE OF CONTENTS

Part 1: Background
 Natural History Books and Info-Graphics 11
 Metaphor 13

Part 2: Inquiries
 Lace, Veil and Mental Structures 17
 River and Creative Inquiry 25
 Corals and Learning 39
 Bees, Transdisciplinarity and Arts Integration 59

Lenses on the Four Areas of Inquiry

Part 3: Conclusion
 Passage to New Inquiries 83

References
 Constructivism and Social Constructivism 87
 Transdisciplinarity 89

Part 1: Background

NATURAL HISTORY BOOKS AND INFO-GRAPHICS

The Illustrated Guide to Integrated Learning was inspired by the field study journals of Natural Historians like Alexander Von Humboldt. In their journals, these scientist/artists recorded and Illustrated the natural curiosities they found in their travels. The texts and images they created relayed information about natural phenomena. Visual and verbal modes not only conveyed information, they also were tools for conceptualizing ideas and developing theories. While the words explained, the images displayed. As scientific illustrations, the images were early info-graphics: storytelling through notated, stylized pictures. Natural historians found "picturing" helped them to understand and find meaning in the things they discovered.

In this Guide, words explain and pictures represent Ideas related to learning, creative inquiry and arts integration, which come together under the umbrella of Integrated Learning. In making this guide, I came to understand my topics more deeply and to see them differently.

METAPHOR

This guide is the outcome of art-based inquiry; it emerged from a process of applying art methods, forms and creative strategies to scholarly research. The creative strategy that propels the Guide is metaphor.

Metaphor is the casting of one thing as another. It is not simply a substitution of one thing for something similar to it. Rather, in a metaphor, the characteristics of one entity are ascribed to another, and the two entities become inextricably linked. Metaphors help us to explain and clarify things. They also enable us to see things differently. Beyond that, a metaphor can attach an abstract concept or process to something concrete and visible. This enables us to understand them better.

In the Guide, metaphor supplies the imaginative thread that attaches concepts of learning, inquiry and integration to tangible living or natural things, and these metaphors are examined and illustrated in the mode of natural history.

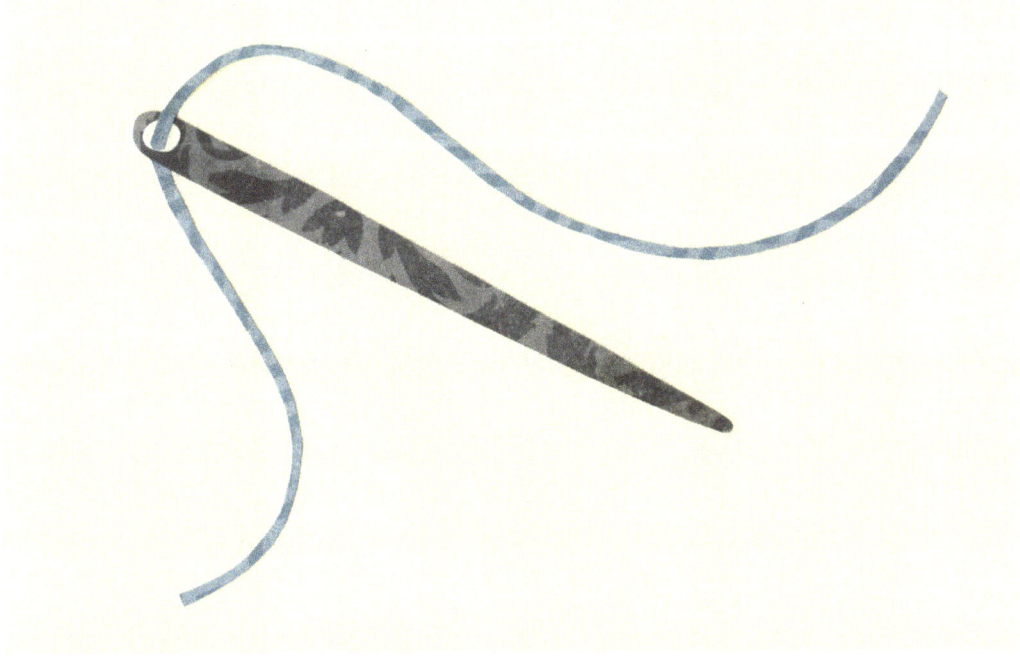

Part 2: Inquiries

Lace, Veil and Mental Structures

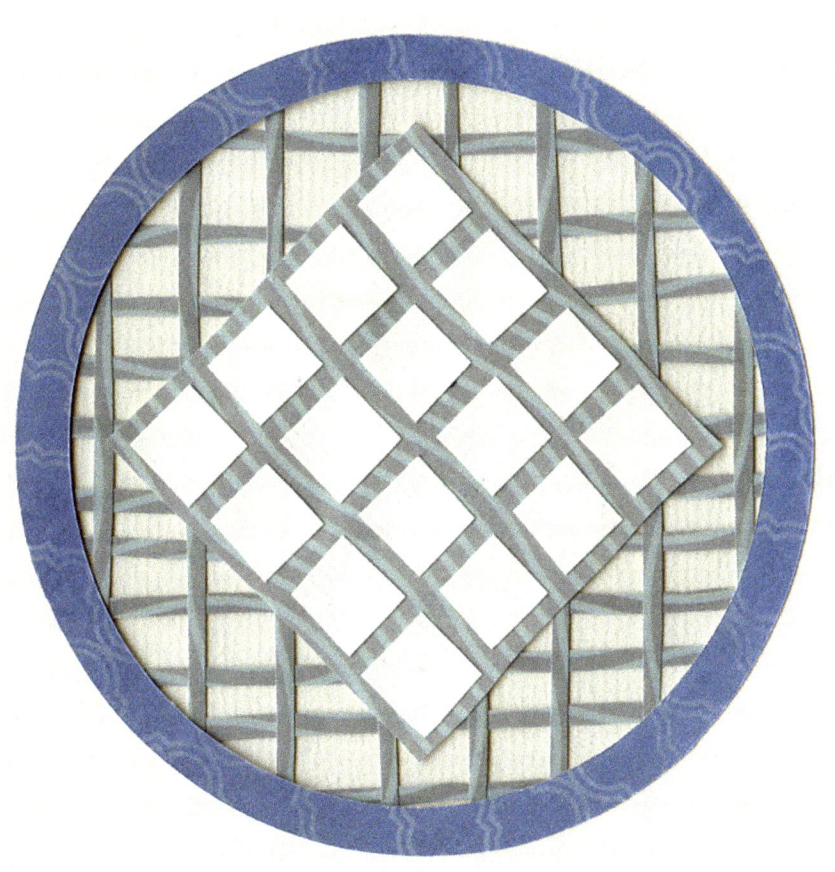

LACE, VEIL AND MENTAL STRUCTURES

Our study begins with a brief examination of our cognitive structures and how the mind learns. The theories of Jean Piaget provided the foundation of current Constructivist thinking about how the mind works. Jean Piaget used the term "schema" to describe the basic structures of the mind. He argued that the mind forms schemata by organizing experiences and impressions into categories. As a young mind encounters the world, these schemata grow in number, diversity and complexity. This assembly of schemata is a flexible "integrated operational structure," a framework on which the mind organizes and understands its experiences. It is the structure on which subsequent experience is integrated into an ever-emerging vision of the world.

The metaphor that best represents schematic structure is lace. Why lace? The characterization of mind as an arrangement of schemata that is flexible, structured and integrated suggested to me a supple net of interwoven threads, while the concept of classification implied patterns of windows suspended within that net. The flexible nature of a net, while it maintains a core structure, allows for different patterns to emerge as it folds and moves. The notion that we see through our schemata pushed the metaphor of lace further; lace became a veil, a cognitive curtain that screens our "vision."

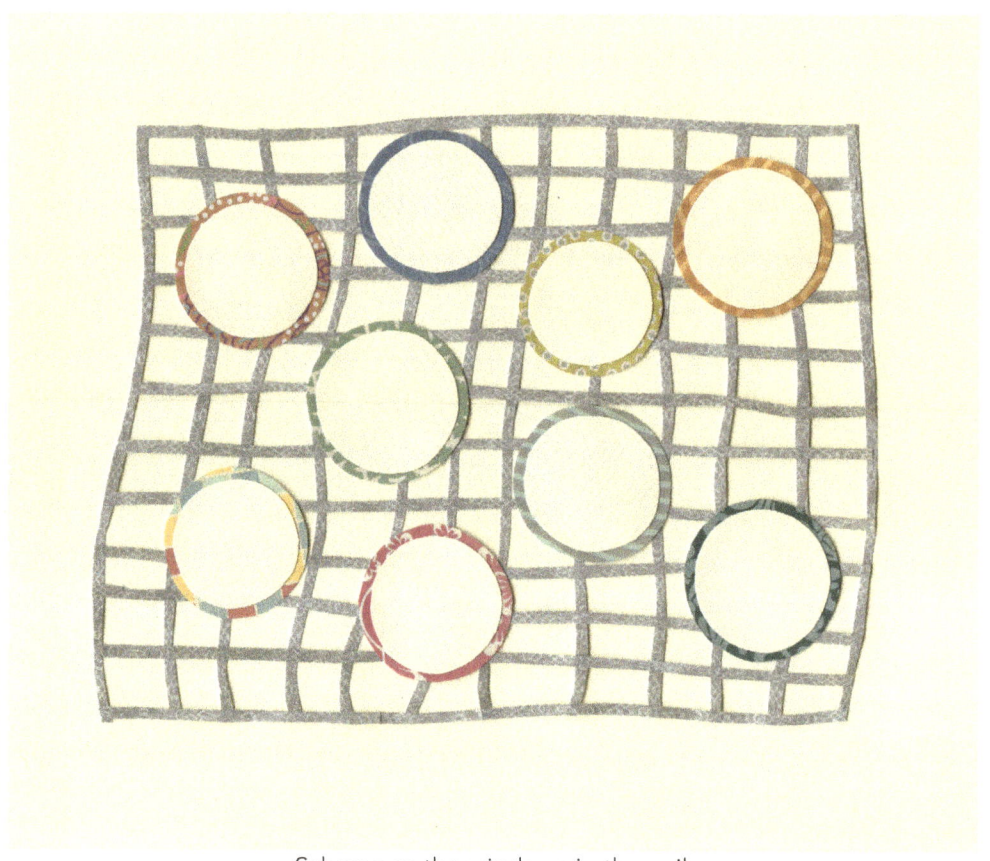

Schema as the windows in the veil

Piaget's schema theory resonates with Perkins' Theory of Understanding. Perkins argued that understanding something entails seeing it in the context of all things related to it—in Piaget's parlance, as a centerpiece of an extensive schema. The term "understanding" has special meaning to Perkins; it is not a matter of seeing something clearly, but of grasping it complexly. This notion of understanding implies that the more we know about the people, places, times, ideas, events and things related to an entity, the more we understand it. Perkins provided a metaphor for his notion of understanding when he wrote that understanding is seeing something within its web of relationships that give it meaning. With this, Perkins brought the metaphor of webbing to the metaphor of lace.

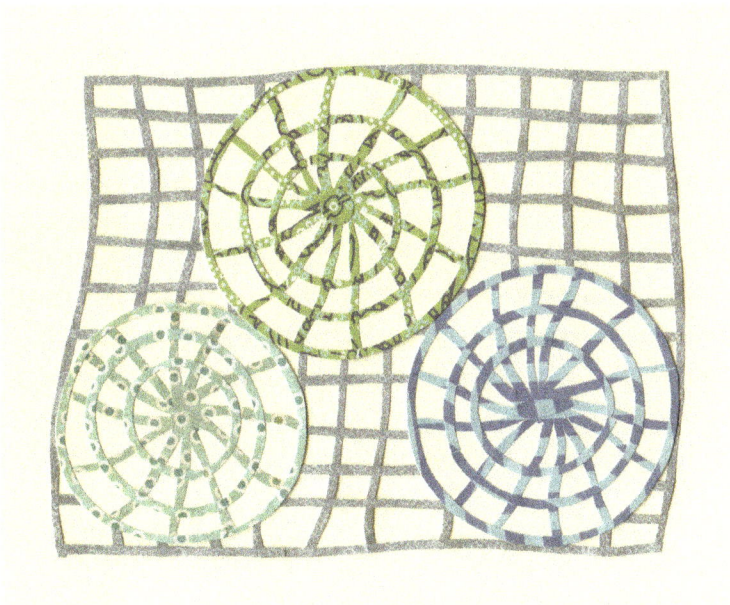

The Veil and Perkins' Webs of Understanding

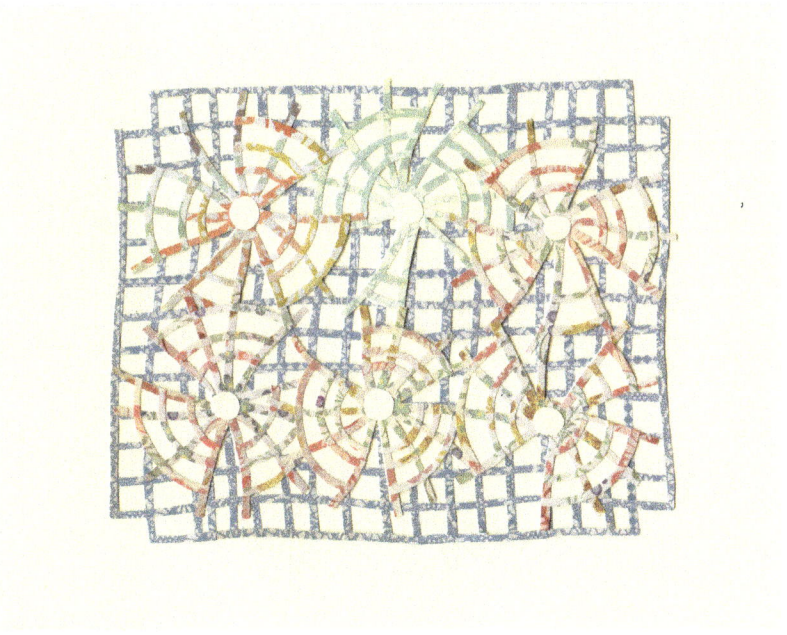

Multiple Webs of Understanding and Meaning

The mind is a filigree of webs.

Learning: Constructing the Webs

Casting understanding as a web adds another dimension. Learning becomes the act of spinning and the learner becomes a spider. How does a learner/spider spin her web? Piaget identified two modes of learning: assimilation and accommodation. Assimilation comes into play when a learner encounters something new that fits into an established schema. The schema expands. Accommodation, on the other hand, takes place when the learner encounters something that does not fit an established schema. When this occurs, the learner must adjust a schema or create a new one to fit the new reality. Schemas change or multiply. Assimilation and accommodation are complementary processes and equally essential to comprehending and navigating the world. When we attach the concepts of assimilation and accommodation to our web metaphor, we behold a learner-spider weaving contrasting forms of webs.

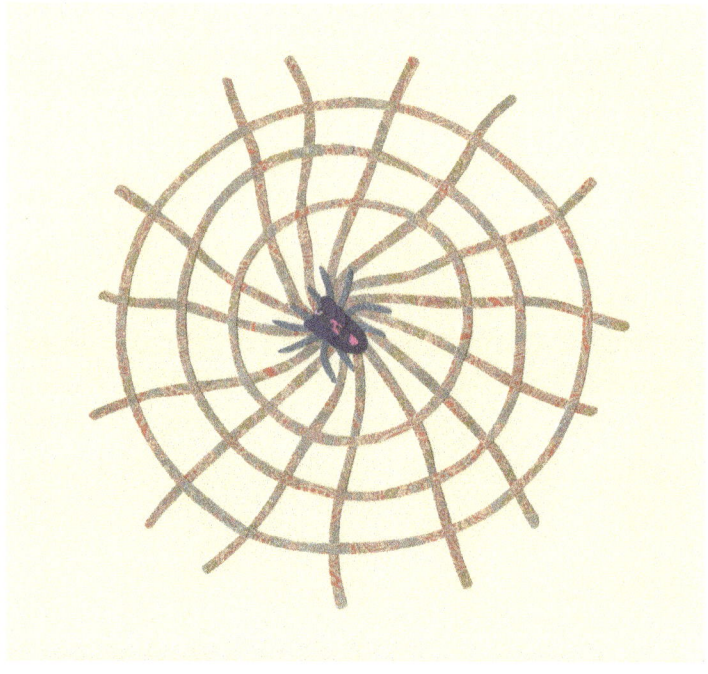

Assimilation

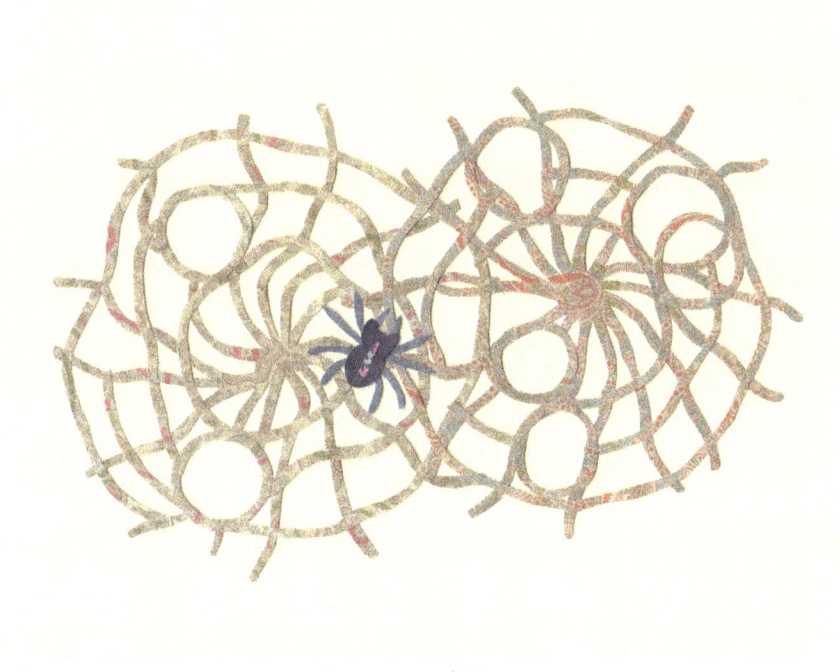

Accommodation

These web structures, while following a general radiating pattern, are also unique to each spider. This introduces the concept of individuality; each spider spins her own composition according to her own proclivities, perspective, environment and experiences. It also implies structural mutability, the notion that the configuration of the web is not fixed or inevitable. The structure of the web fluctuates because a spider's work is subject to change. As she spins, the spider revises, edits and reconfigures her patterns in response to new experiences, knowledge and discoveries that surprise, perplex or otherwise disrupt her order. Thus her web evolves in an organic, recursive, and often apparently capricious way.

The River and Creative Inquiry

THE RIVER AND CREATIVE INQUIRY

Creative Inquiry is a river.

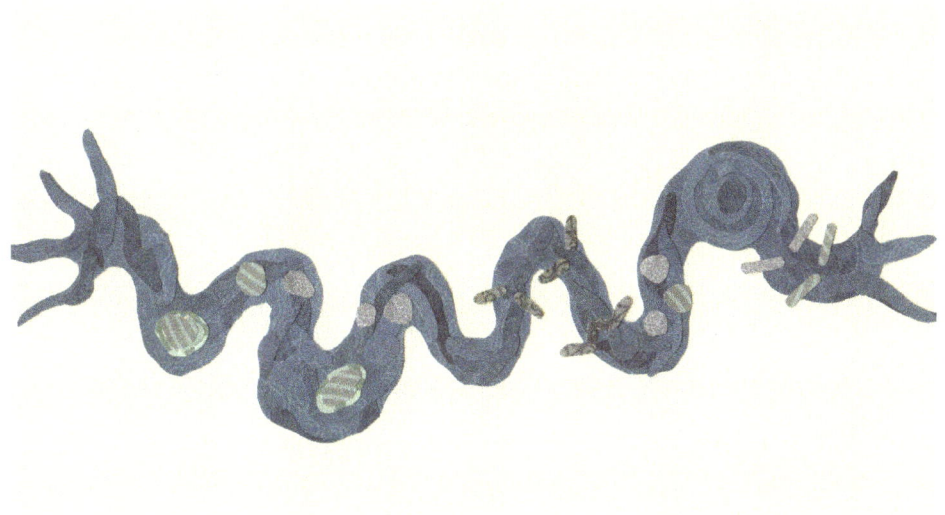

Casting creative inquiry as a river taps into a river's web of associations. A river begins in a lake or a confluence of springs or tributaries (the source: questions and purpose); it flows toward a body of water (it has intention). A river generally stays within its banks (a discipline's norms, frameworks and methods) but it occasionally floods, spilling over its banks (going outside rules, expectations and customs); it can alter its channel (rethink ideas and methods); and it can change course (revise its direction and parameters).

As a river runs, it splashes into rocks and fallen trees (encounters setbacks and challenges); it plunges over waterfalls (encounters surprises and hurdles that can cause chaos); it widens into lakes (expands the inquiry); it flows into deep still pools (slows down for reflection); it travels through sluices (it narrows through editing and distilling); and it forms into whirlpools (it revisits and revises ideas and conclusions).

Through all of this, the inquiry river creates new ideas and knowledge by carving soil along the banks (reveals hidden layers of ideas, information and meaning); it shifts earth (creates new categories and perspectives); and creates and supports ecosystems that live along its banks and on its bed (generates and sustains integrated ideas and thinking).

The river metaphor also incorporates other aspects of creative process. It summons notions of swimming, floating, navigating, fishing, frolicking and drowning. The metaphor takes on more meaning when words associated with inquiry, thinking and learning are mapped along the river. Words like: question, search, collect, examine, experiment, analyze, sort, distill, infer, envision, connect, hypothesize, revisit, re-think, revise, extrapolate, edit, organize, construct, conclude, and document. Here is a map of the river with words that describe what thinking occurs as we navigate the river.

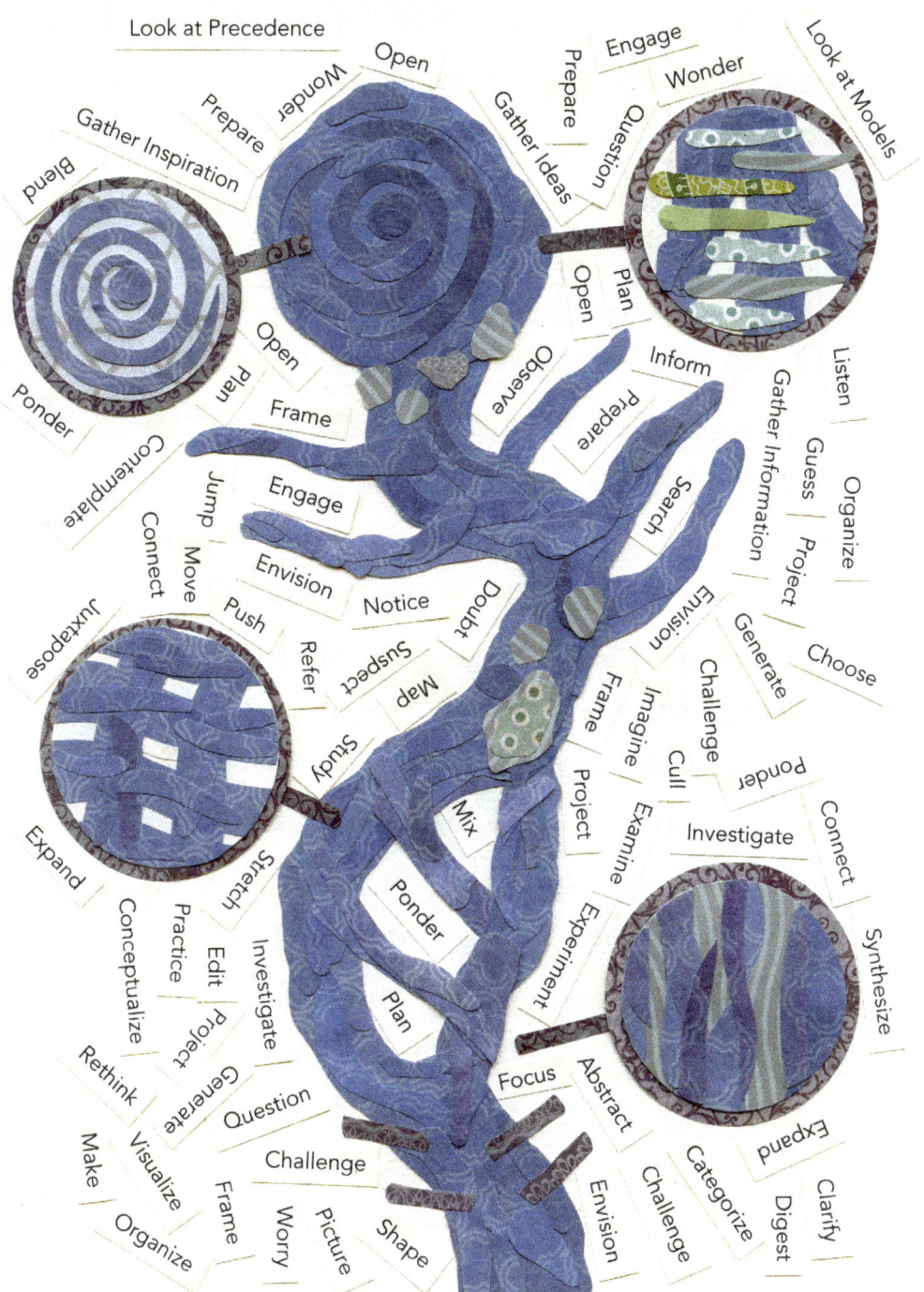

Inquiry River, Part 1 of 4: The Source and Headwaters

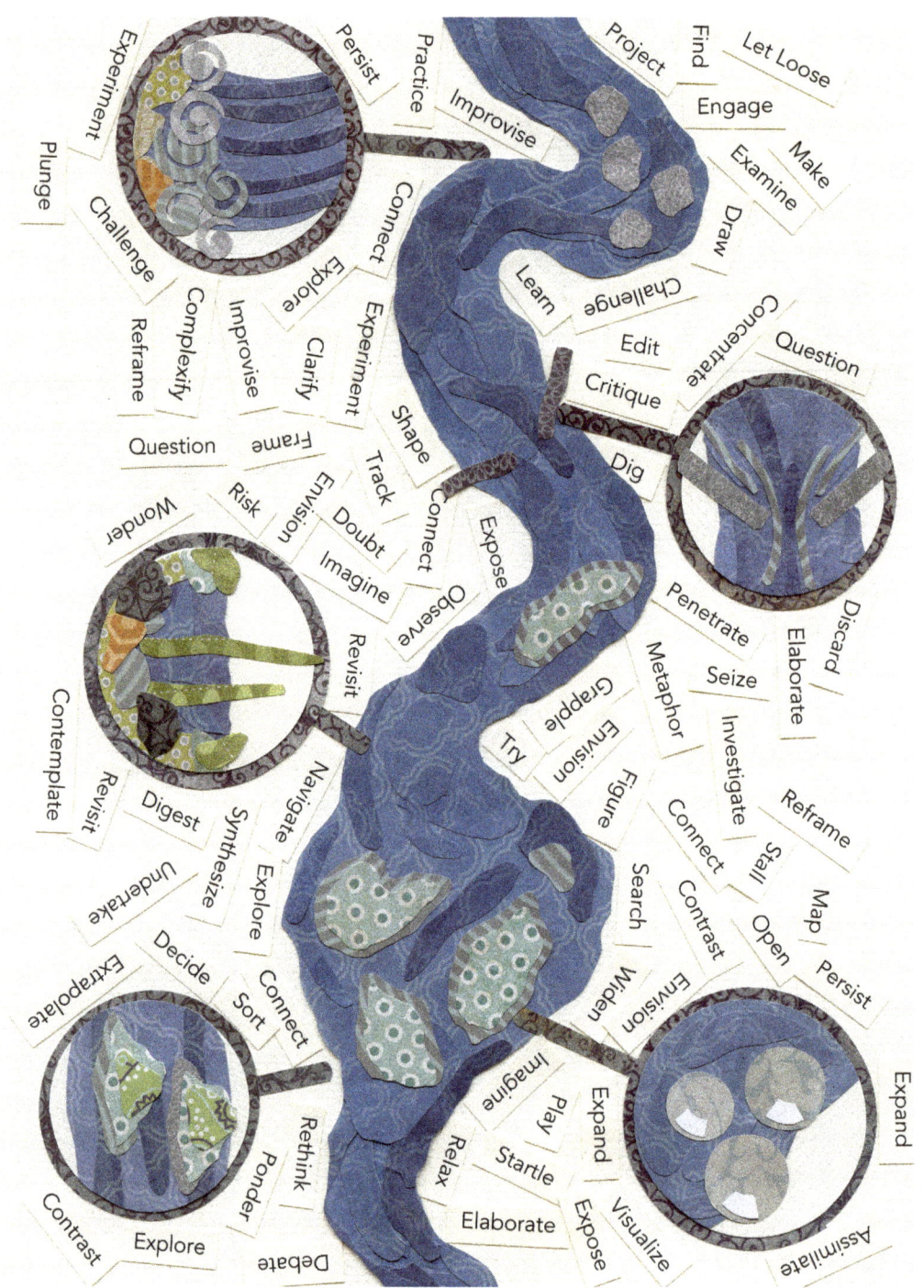

Inquiry River, Part 2 of 4: The Upper River

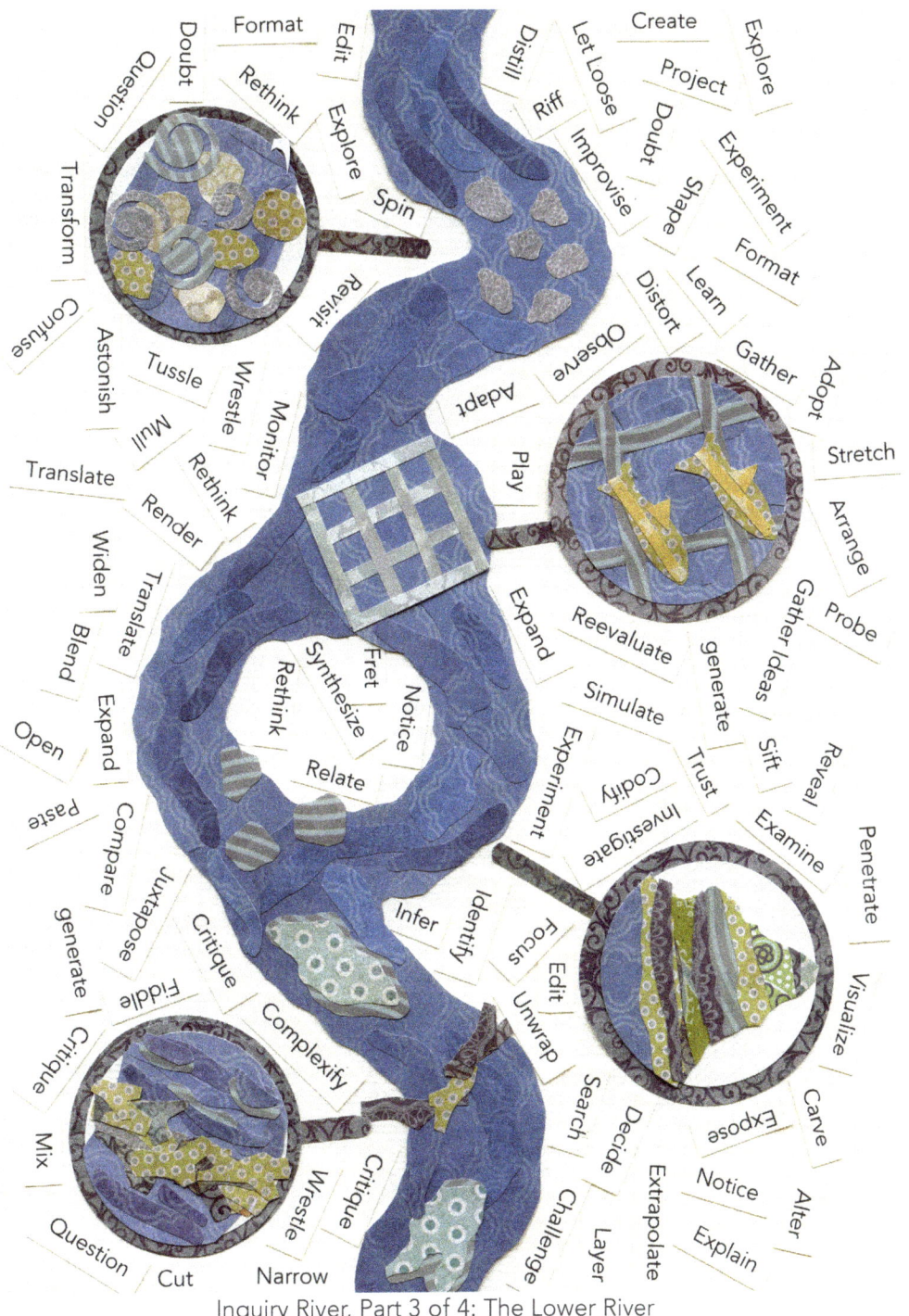

Inquiry River, Part 3 of 4: The Lower River

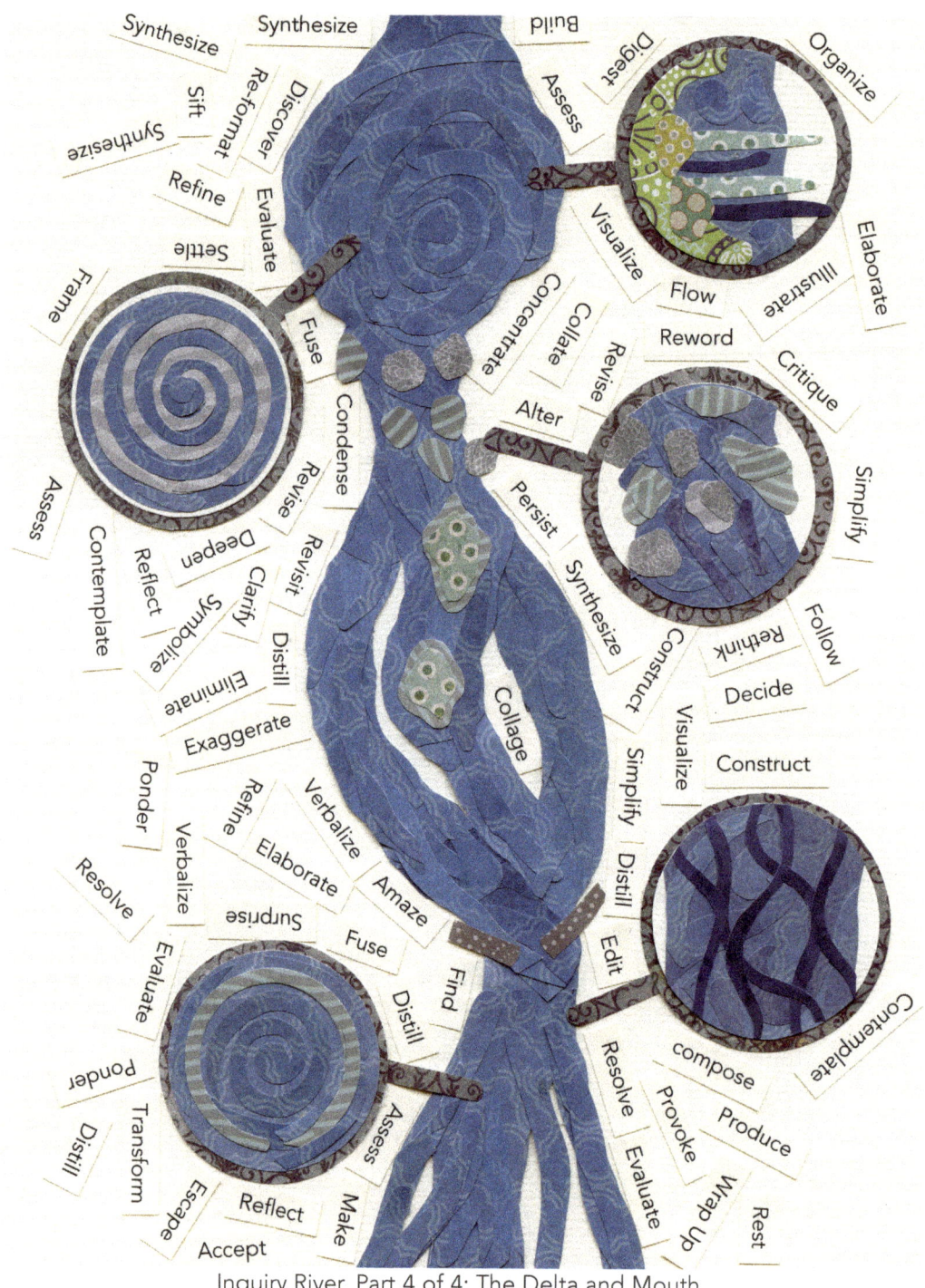

Inquiry River, Part 4 of 4: The Delta and Mouth

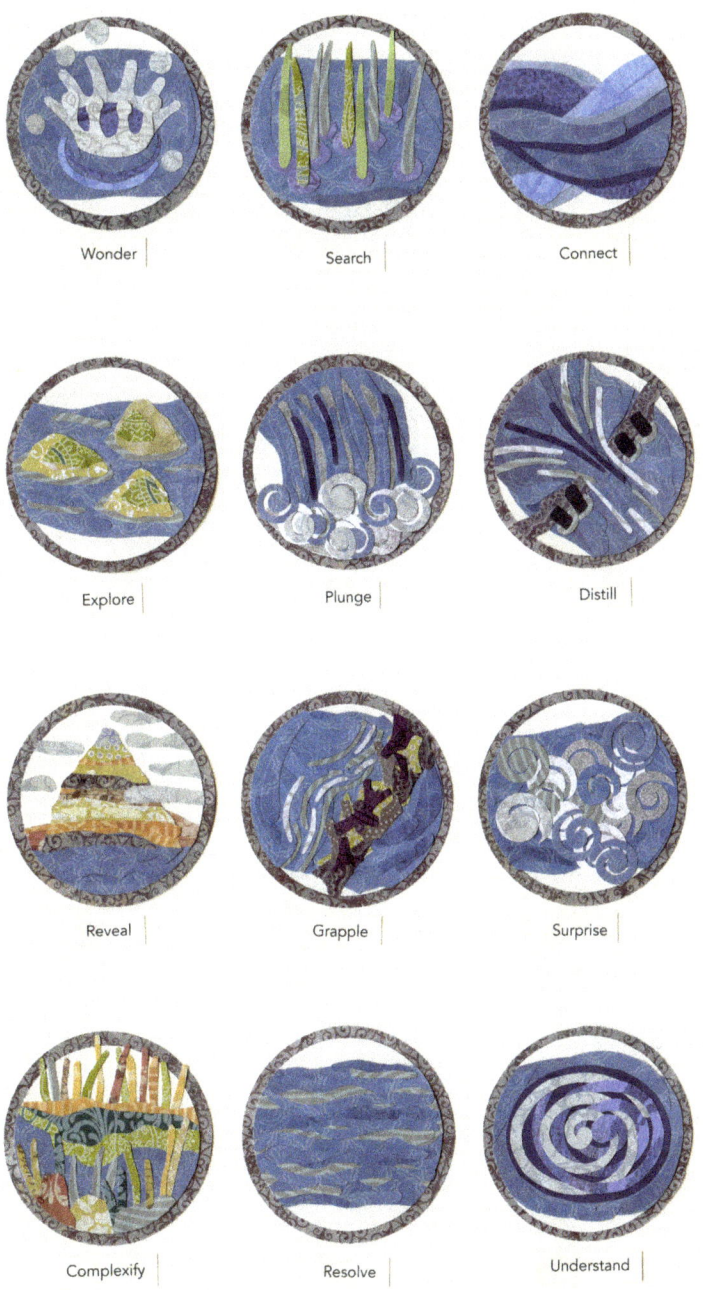

Sites and Processes Along the River

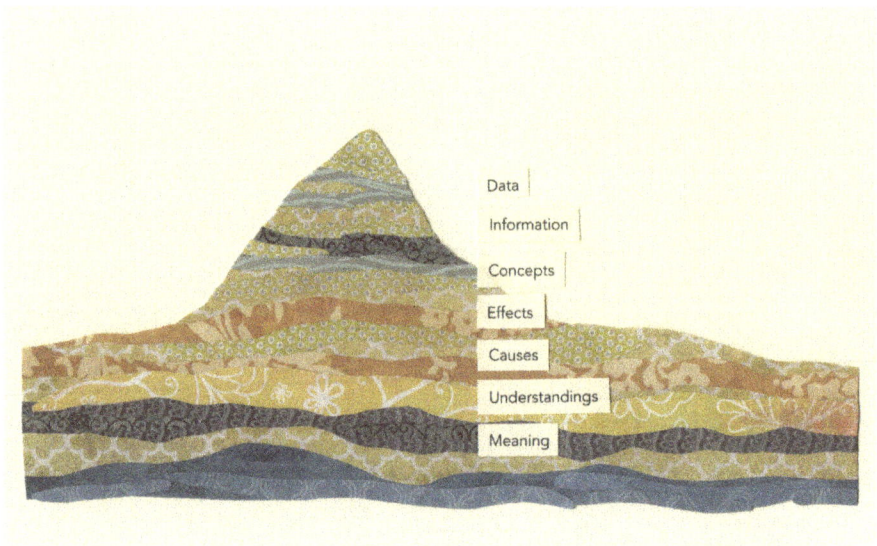

The Information Geology of the Banks

The river carves its banks to reveal levels of information and meaning—from the most concrete and direct to the most complex and illuminating.

View From the Depths

New knowledge and meaning arise when a researcher dives deeply.

Deepening the Connection to Complexity, Systems and Chaos Theory

There are deep connections among rivers and inquiry, and systems, complexity and chaos theory. In regard to systems and complexity theory, the river aptly represents the concept of system because it is an ecosystem composed of a continuum of interrelated smaller ecosystems that fills its waters and line its banks. A river's ecosystems can be equated to the systems of information and ideas an inquiry explores and pulls from as it progresses.

Apropos chaos and complexity theory, the river embodies emergence, the concept that phenomena arise through a progression of multiplying feedback loops. The term emergence describes well how understanding develops in inquiry, how it accumulates and evolves through dynamic interactive flow of ideas and thinking.

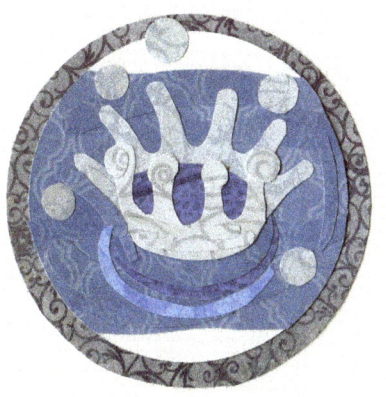 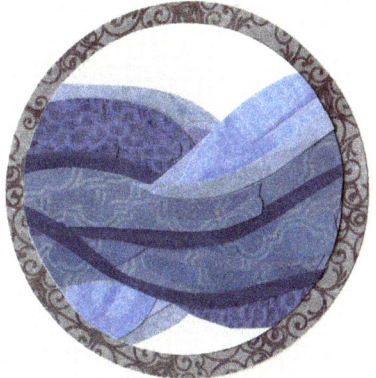

Perhaps the deepest connection between the river and chaos theory, lies in the nature and power of water. Water creates and shapes a river; it flows in dissipative structures such as currents, waves and whirlpools. Indeed, a river's current is a dissipative structure in itself—flowing on the edge of disequilibrium and yet maintaining its form. Above all, water is a particularly apt metaphor for poietic logic. Poietic logic is the blending of linear, logical thinking with associative imaginative thought. Poietic logic is to inquiry as water is to a river. It is the substance and the force that shapes, propels and animates creative inquiry. It is its medium of its fusion and flow.

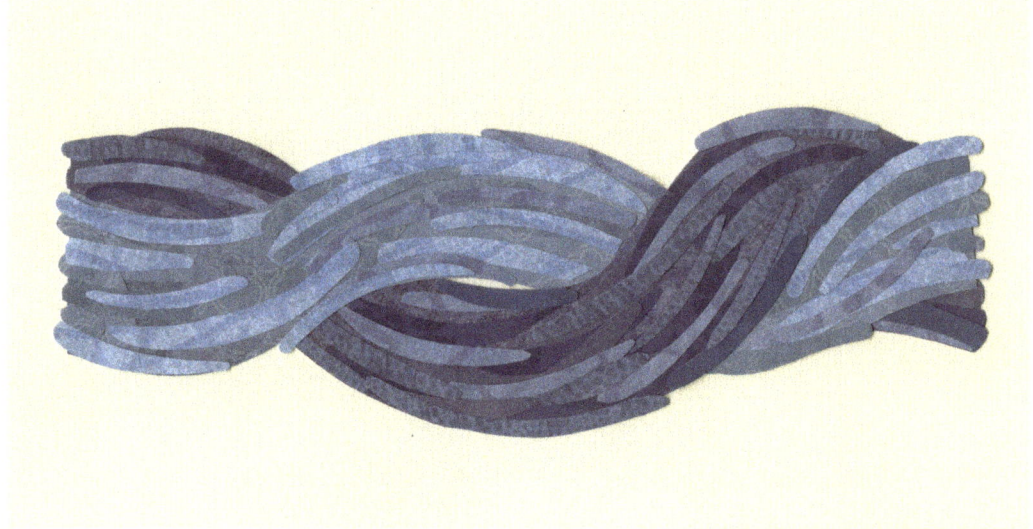

Poietic Logic

Poietic Logic enables the researcher to find poetry and possibility in everything she explores.

Creative inquiry is integral to all disciplines that break new ground and generate new knowledge. Creative inquiry varies among disciplines, but the different versions of it share traits illuminated by the river metaphor. A map of comparable rivers conveys this:

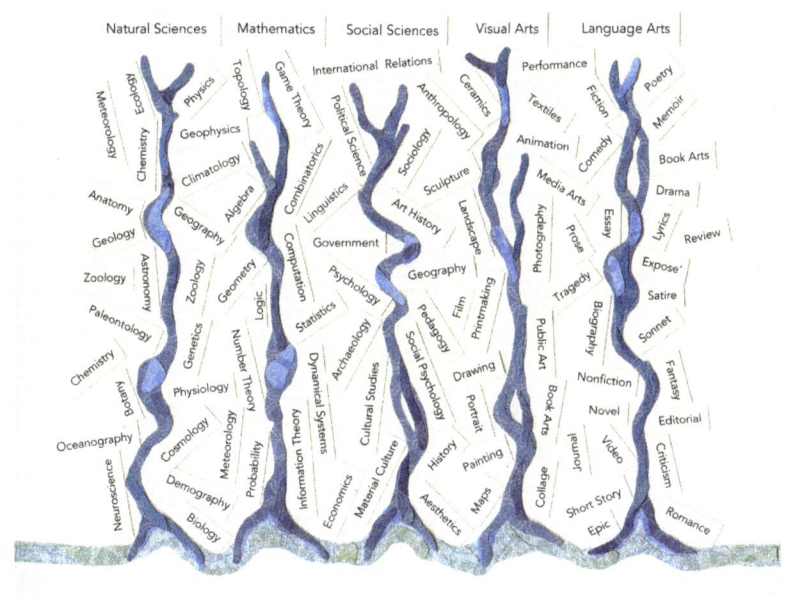

Multiple Disciplinary Rivers

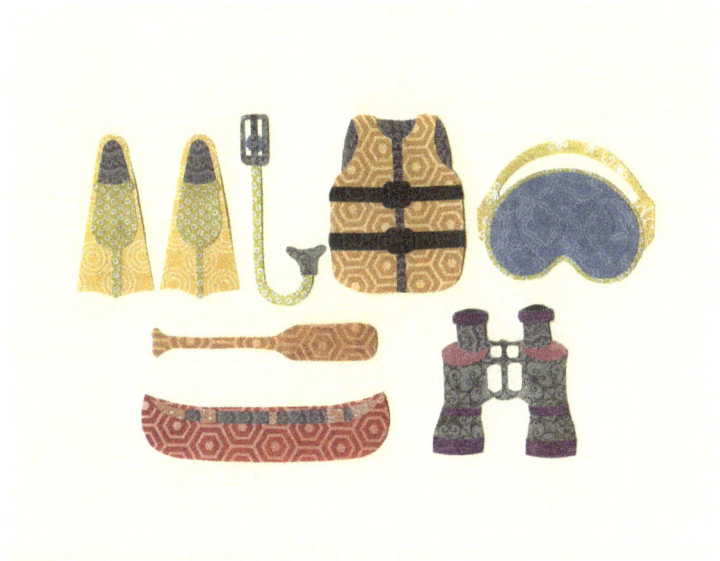

Research Tools

How do we navigate the river of inquiry? Here are some tools.

Personal Connections

Connecting creative inquiry to a river took me back to my childhood memories of a trout stream in northern Wisconsin. This metaphor allowed me to draw on what I knew and loved and to connect creative process, something as an artist, educator and writer, I experience, enjoy and struggle with frequently, to a place and a force of nature I played in, dwelled in, and drew inspiration from when I was young. The river metaphor, not only enhanced my understanding of inquiry, it also helped me to become metacognitive about my process, thus enabling me to face the challenges and joys of research, whether I am writing, teaching or making art.

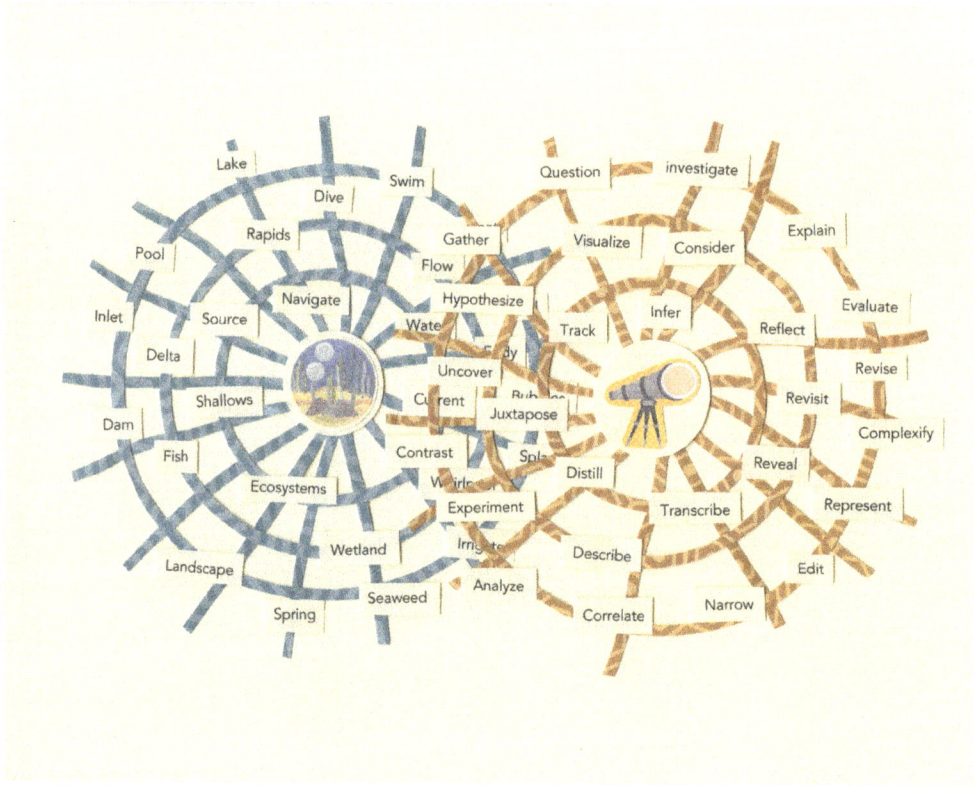

Overlapping Webs of River and Inquiry

Corals and Learning

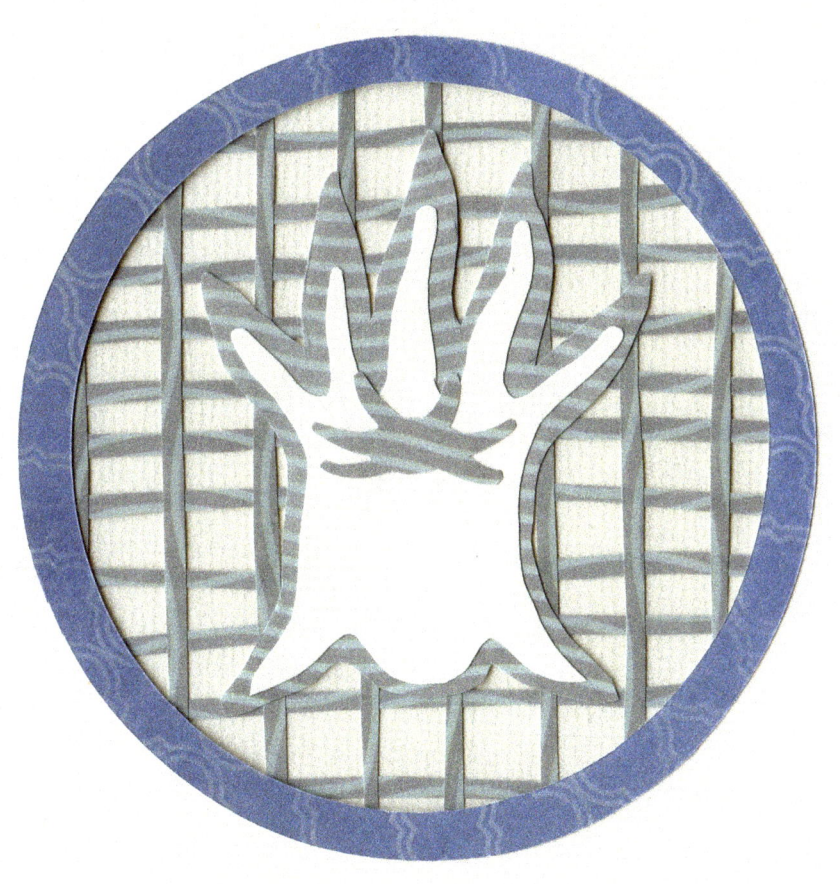

CORALS AND LEARNING

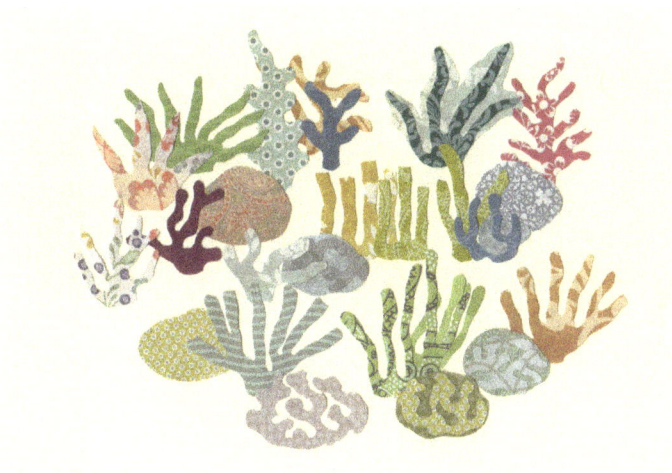

I was first drawn to corals because I sensed a correlation between corals' lattice-like structures and the concept of schema proposed by Piaget. This initial link led me to see schema in a new light, as both a support structure and as the outcome of living. Unlike the spider metaphor, which sees learning as a construction by a creator, the coral metaphor reframes it as a natural outcome of growth and interactivity.

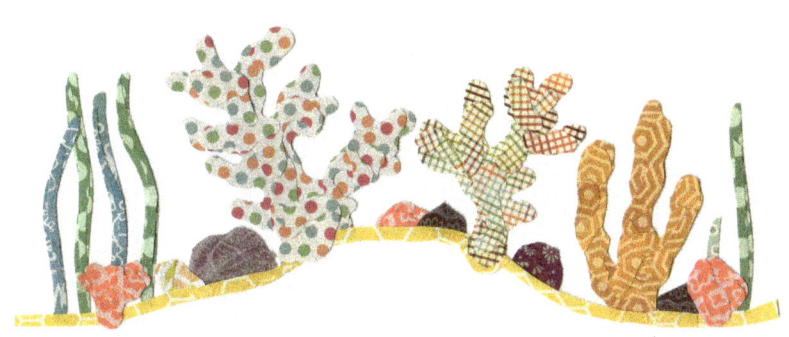

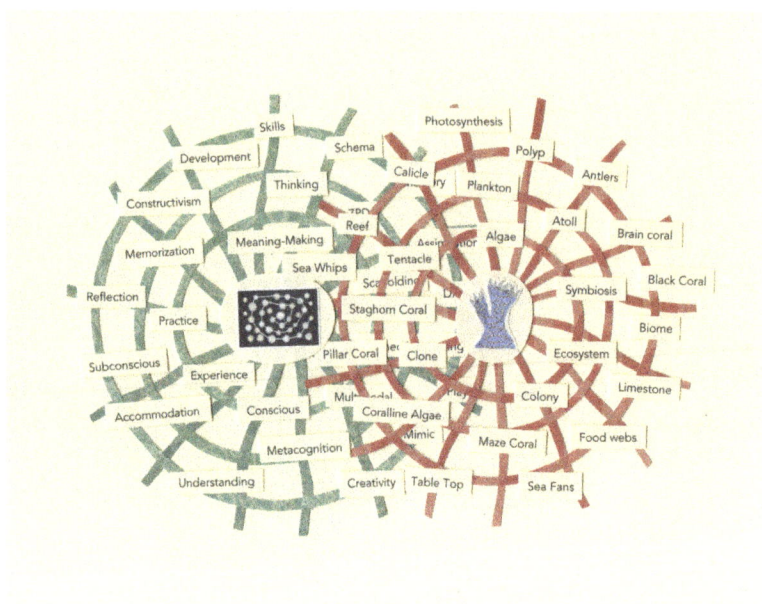

Webs of Associations: Corals and Learning

Unlike the lace metaphor, which is simple, the coral metaphor is complex. Its complexity has two effects: a complex metaphor is far more generative than a simple one (it brings a full set of entailments), and applying it requires more research (to utilize all those entailments).

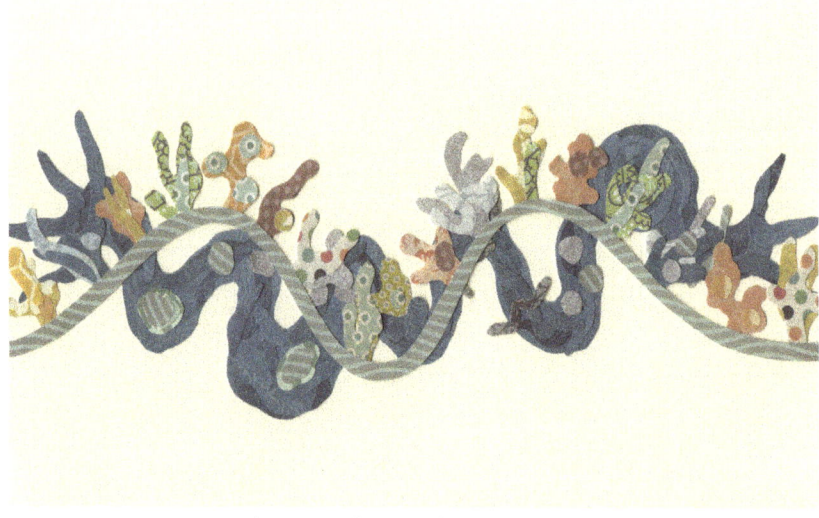

Dual Research: Corals and Learning

Constructivist Learning Theory

Constructivist theory arose from the late theories of Piaget discussed in Chapter One. Constructivism has since evolved into a comprehensive explanation of how the mind works and learns—as an interior phenomenon that is deeply influenced by social interaction and culture. Constructivism maintains that learning is an active process in which each learner builds her own knowledge. Learning is triggered when a learner, responding to stimulation, connects new experiences or information to prior understandings. In a nutshell, learning is an organic process of development in which each learner constructs her own reality.

Corals

Coral polyps are tiny sack-like marine animals with tentacles related to sea anemones and jellyfish, who secrete and live in cup-shaped exoskeletons, which they leave behind when they die. Over generations of polyps, these exoskeletons accumulate and form into intricate web-like structures of corals.

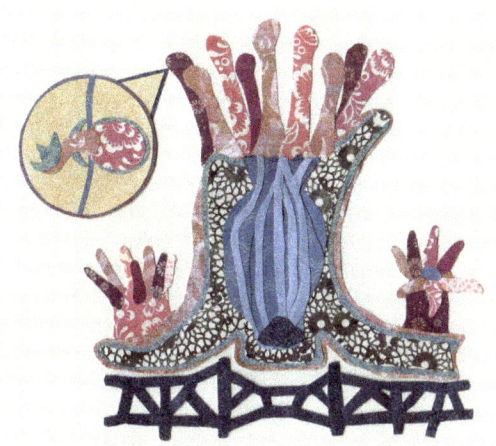

Anatomy of a Coral Polyp

Viewed through the coral metaphor, learning is a living process. Polyps are learners whose learning is constructed and maintained by a combination of interior workings or actions (digestion and metabolism) and influences from the outside (the nutrients that float into their tentacles). Coral life entails taking in and digesting nutrients, responding to environmental changes and disruptions, adapting when necessary, and constructing structures that are shaped by the processes that form them. These are all traits attributed to learning by Constructivist theory.

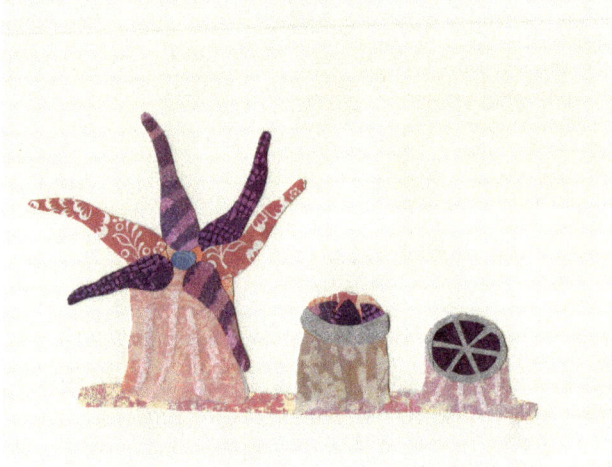

Bestowing the Exoskeleton

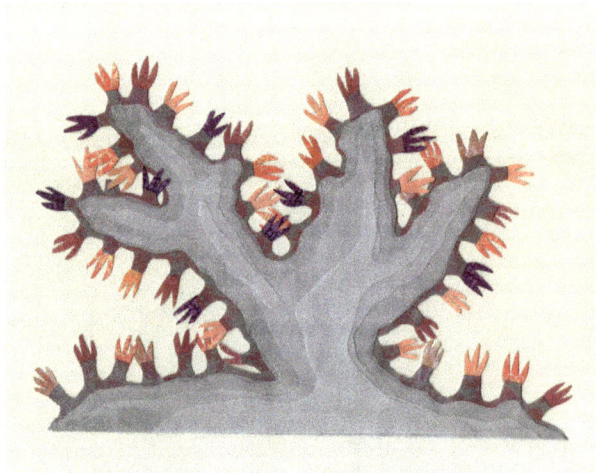

Cross Section of a Coral Structure

Learning is often conceptualized as a recursive spiral that entails first encountering, then revisiting and revisiting again, each time in a different, more sophisticated way. Educators often organize recursive-learning segments to build on this understanding of how learning works in a spiral of progressive phases or steps.

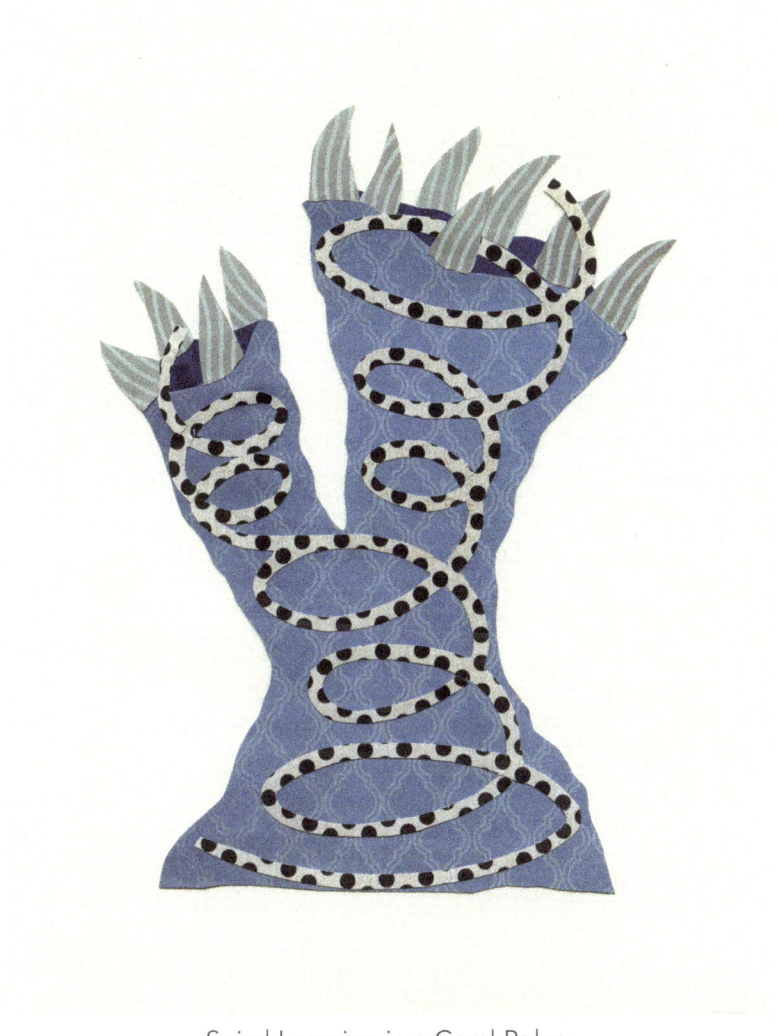

Spiral Learning in a Coral Polyp

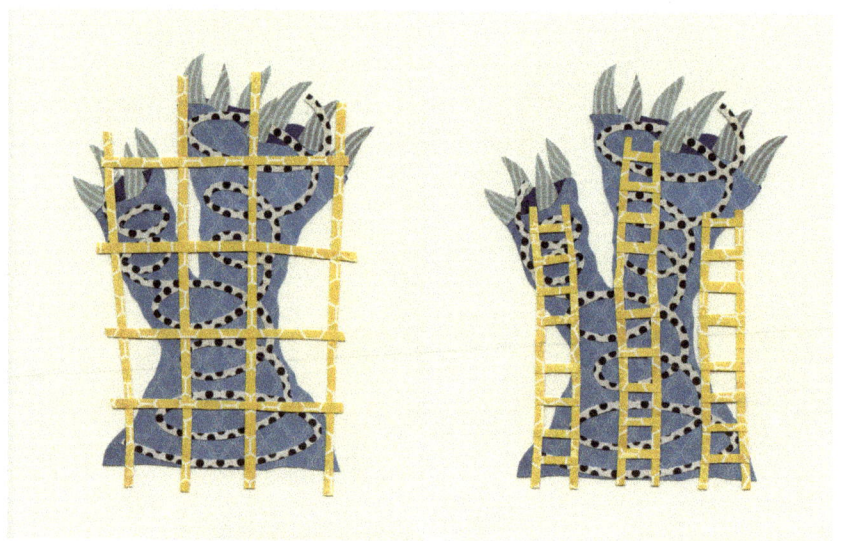

Scaffold Learning

The coral metaphor invites play with other ideas about Learning. Assimilation and Accommodation can be seen as the construction of different styles of coral architecture.

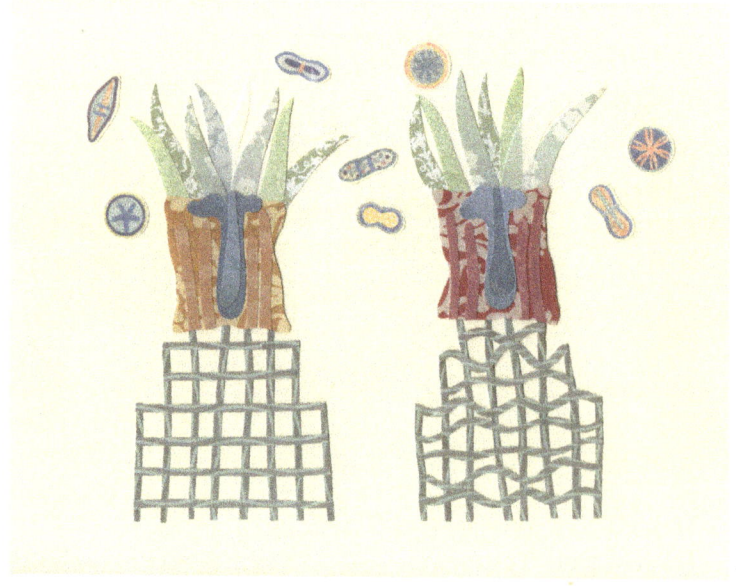

Assimilation and Accommodation

So why not see Blooms Taxonomy through corals? Blooms Taxonomy organizes different levels of thinking, from the most basic to the most advanced.

Here it is illustrated as a multi-tiered coral polyp.

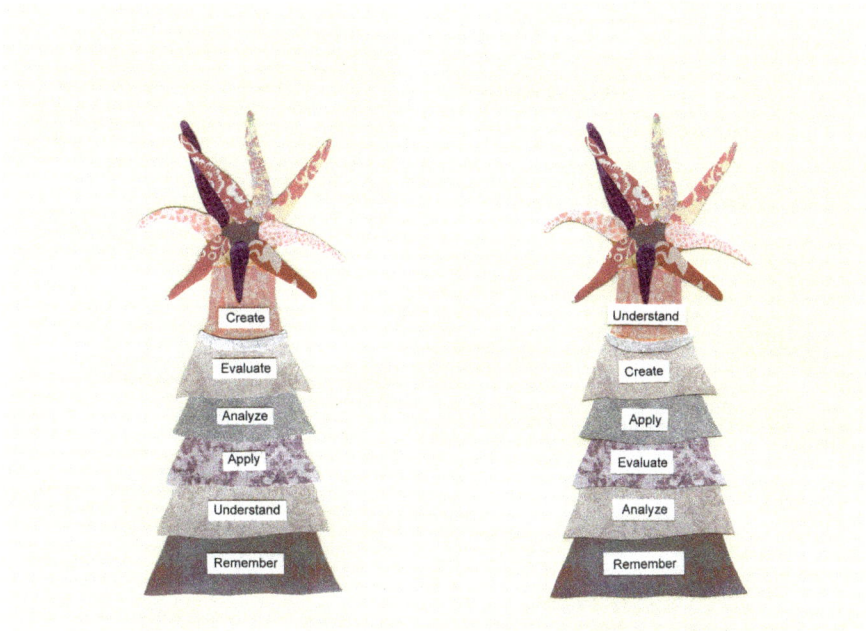

Blooms Taxonomy: Before and After

On the left is the original taxonomy with "create" on the top. On the right is the author's version, which shows "understanding" at the top with "create" beneath. This second polyp symbolizes "creativity for understanding"—using imagination and creative thinking to come to understand. This is the core premise of art-based learning and inquiry.

Just as learners construct progressively complex mental structures, coral polyps build stony intricate architecture. This lacy lattice comes to signify the mind. That is, the mind is embodied in the physical forms of corals.

Hyperbolic, Non-Euclidian Nature of Learning

The structures corals create reflect the principles of Chaos Theory, particularly the concept of emergent growth in recurring fractal patterns of self-similarity and seeming randomness. The pronounced hyperbolic geometry of coral latticework provides a palpable embodiment of this phenomenon. Learning, therefore, as represented in coral forms, is a complex, organic, recursive and self-creating process that is often unpredictable, and difficult to measure by rigid or regular metrics.

The variety of corals alludes to different ways of learning and to the diversity of understandings or perspectives learners construct. In regard to learning, learners acquire skills and knowledge in multiple ways (reading, observing, memorizing, mimicry, experimenting, problem solving, discovery, visualizing, mapping, talking, writing and embodying). Corals, in all their diversity of shape, kind and color represent this diversity of process. Regarding multiplicity of perspectives, the wide variety of coral structures also characterizes how individual learners organize and conceptualize their understandings in various differing ways. No coral is exactly the same; learners have different perspectives—different understandings.

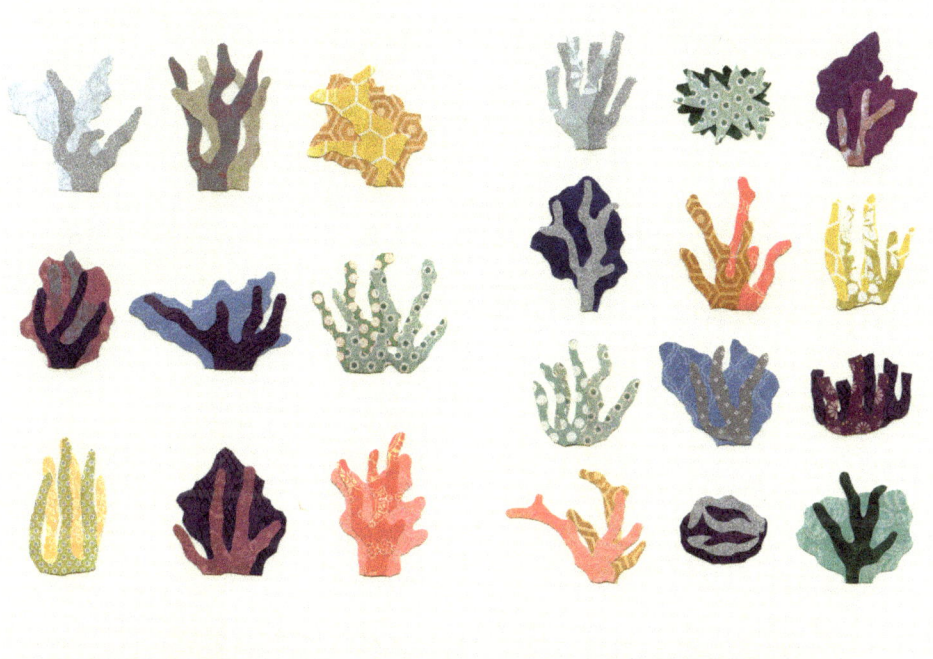

A Loose Taxonomy of Perspectives & Ways of Learning

Social Nature of Learning and Corals

The coral trail now leads to the social nature of learning. A common feature of both learning and corals is symbiosis. In the natural world, symbiosis describes how organisms live closely together in either parasitic or mutually beneficial relationships. In the social world, it connotes a cooperative relationship between two persons or among groups. Symbiosis, therefore, implies connection and cooperation.

Coral polyps are able to live because of their symbiotic relationship with organisms in their environment. Since they are unable to process sunlight independently, coral polyps rely on surrounding algae, capable of photosynthesis, to process energy for them.

This synergy between polyps and algae connects them conceptually to Vygotsky's Sociocultural Theory of Learning, and Bandura's Theory of Social Learning, both of which portray learning as a social process in which learners construct knowledge through interaction with others, including peers and adults. These social theories of learning emphasize mutual interdependence and an individual's reliance on others.

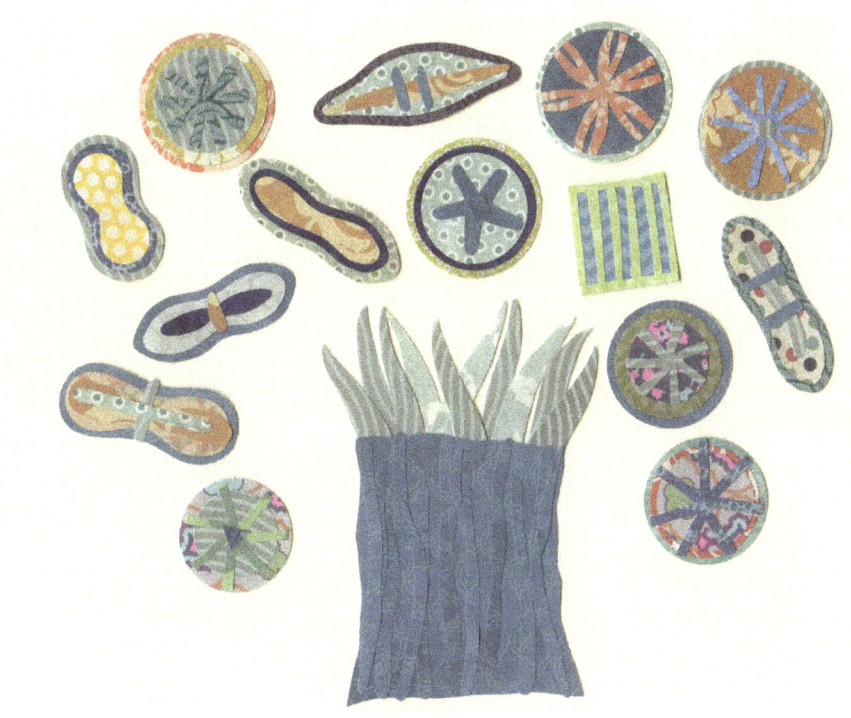

Symbiosis with Other Organisms in the Environment

The influence of others on learning implies a key role in learning for context and culture. Lave and Wenger's Theory of Situated Learning posits that learning is contextual. This expands the circle of influence beyond the one-on-one relationship of learner to teacher to include social, cultural, temporal and environmental factors. Berger & Luckman's Social Constructionism Theory explains this. Each individual learner constructs knowledge by internalizing the knowledge and perspectives of her culture. Her personal development is culturally or socially determined. Vygotsky's Sociocultural Theory echoes this idea. To him, society and culture are the foundation of the individual human intellect or mind; each mind exists as part of a cultural, societal ensemble of minds and is constructed and shaped by the society and culture it inhabits.

Back to Piaget's Schema Theory. It says that existing schema provide a foundation for further learning. From a socio-cultural perspective, culture is a set of schema—the schematic structure that shapes an individual's understanding and perspectives.

A coral colony's underlying architecture is to polyps as culture is to learners; it is the foundation on which new developments arise and it influences the form those developments take.

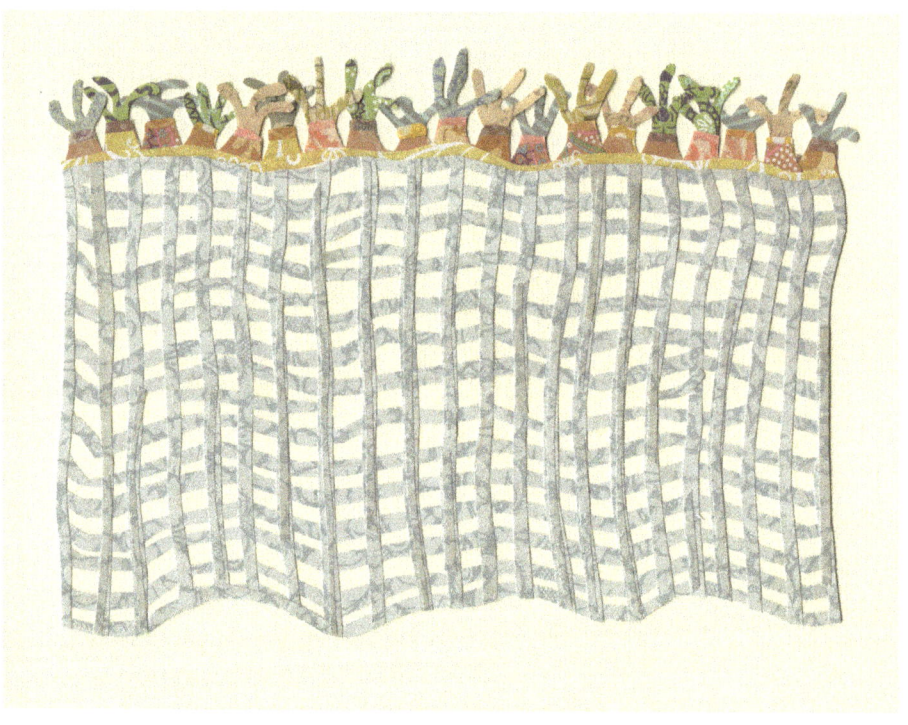

Mutually Constructed Culture and Understandings

If learning is a process of erecting schemata and building webs of understanding, culture is a shared set of schemata or common webs of understanding built by many learners together. Berger and Luckman see culture as a co-construction, a common set of views, values, conventions and practices built over time as each generation internalizes, revitalizes and revises it.

Corals and learning are both constructed collaboratively. Corals evoke the notion of shared structure but also of collaboration in building that architecture. The coral latticework is built over time by generations of polyps working together. This structure also stands for a shared reality—a collective web of understanding.

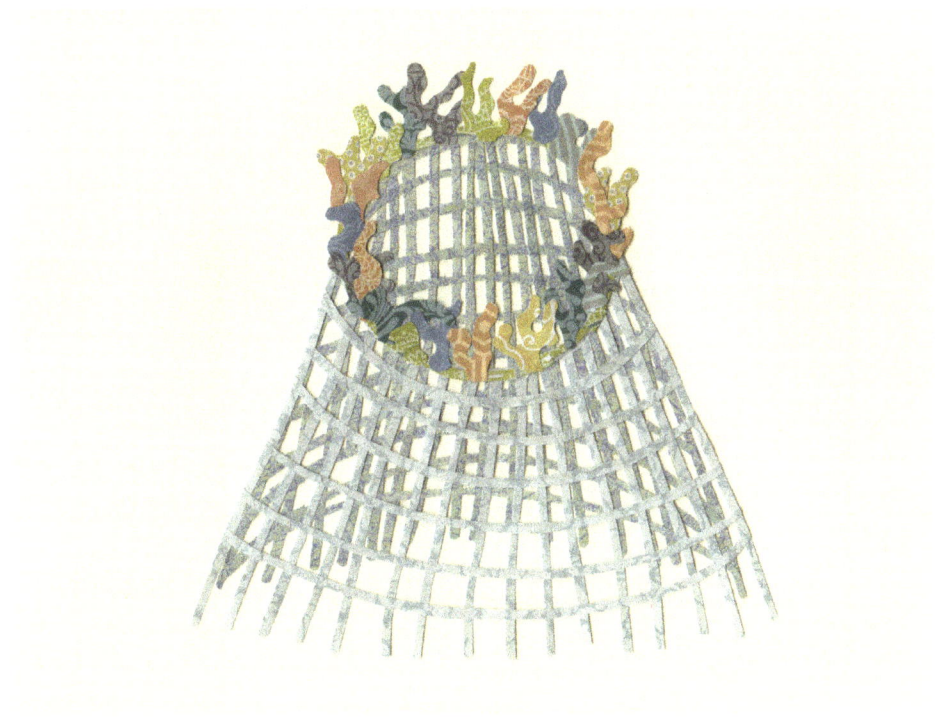

A Mutual Ring of Culture and Reality

Embodied Mind, Extended Mind.

The social perspective on mind and culture connects to systems thinking, and Maturana and Varela's Theory of Embodied Cognition. Embodied cognition has two core theses: First, natural living processes qualify as cognition because they are interactive feedback loops that enable organisms to respond, adapt and sustain themselves. Second, feedback loops also generate and animate systems of systems in the natural world. That is, all living things exist within a holistic system of feedback loops. All systems are also deeply connected to each other, with small systems nested progressively within larger ones. Because this universal system of component systems is an interactive, interdependent web of feedback loops, it too is a cognitive system. The world, therefore, is an "extended mind" and the mind is not confined to an individual's brain, but distributed among brain, body and environment. Here the net is not just in the social and cultural world, but also in the physical and natural world.

Polyps are living examples of embodied cognition; individual coral polyps and structures form reefs and ecosystems—systems composed of tiny organisms in large formations, each module with its own contribution to the cognitive system they live in. In this way, the reef is an apt metaphor for the invisible cognitive networks that extend out of and among living beings, binding and supporting them.

Also, as ecosystems, reefs harbor and sustain varieties of life other than corals, such as fish, seaweed, crustaceans and mollusks. In this way, the coral reef metaphor illustrates the fertility, complexity, diversity and dynamism within the extended mind, and its expansion beyond one system into the world around it. Coral reefs illustrate a systemic vision of mind as an extensive ecosystem.

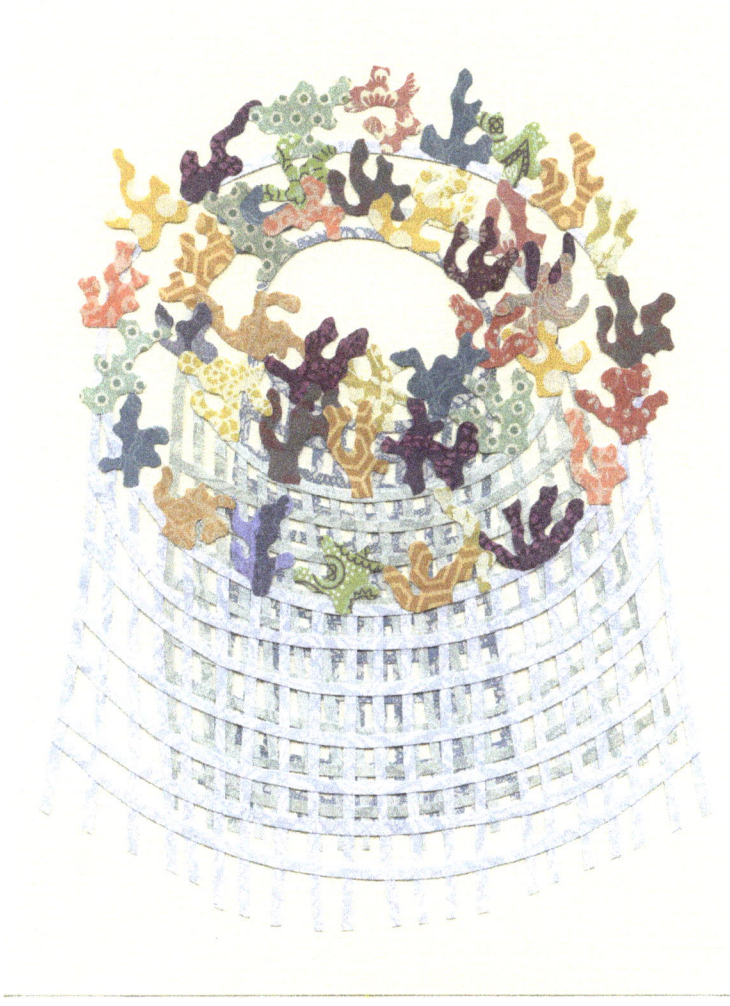

Concentric Ecosystems: Extended Mind

Metacognition

An overarching goal of art-centered learning is metacognition. Metacognition means recognizing one's processes of learning, and being able to shape that learning.

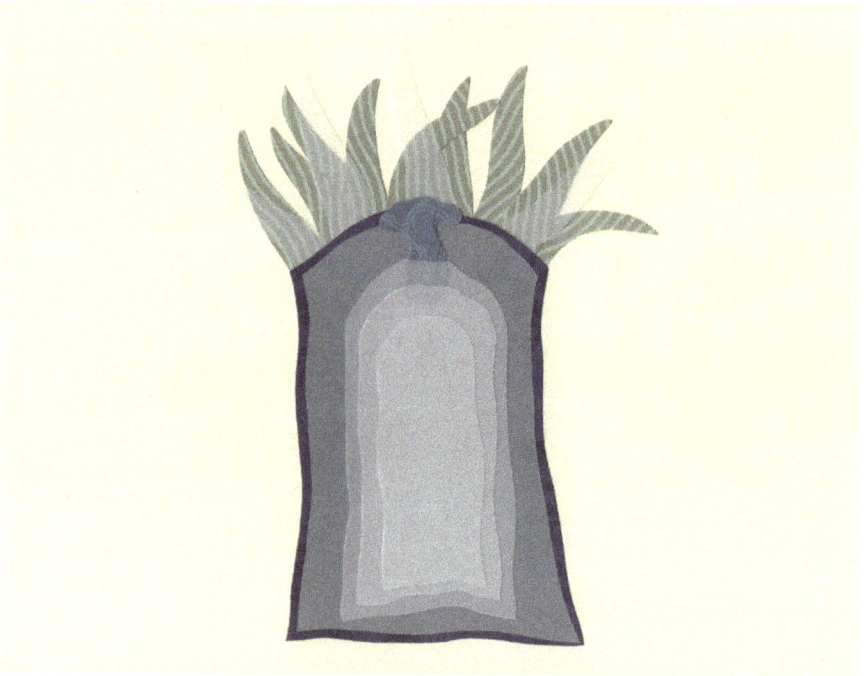

Metacognition: Knowing How One Learns

Metacognition also entails knowing how one fits into the ecosystem. It could be said that a metacognitive understanding of creative process and learning is the ultimate goal of the Illustrated Guide.

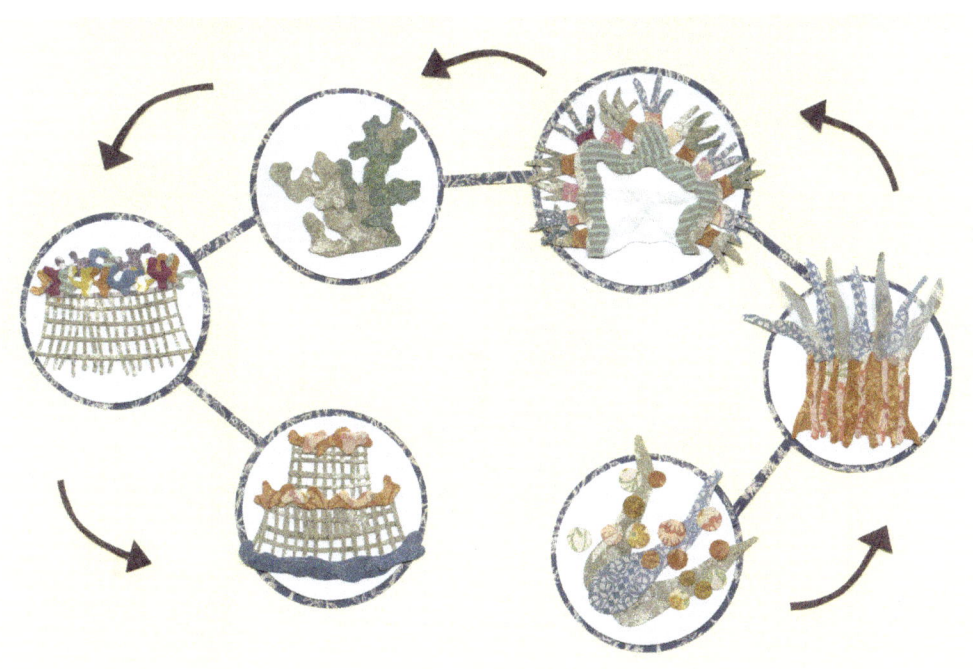

Scale: From the Individual Mind to the Extended Mind

Bees, Transdisciplinarity and Arts Integration

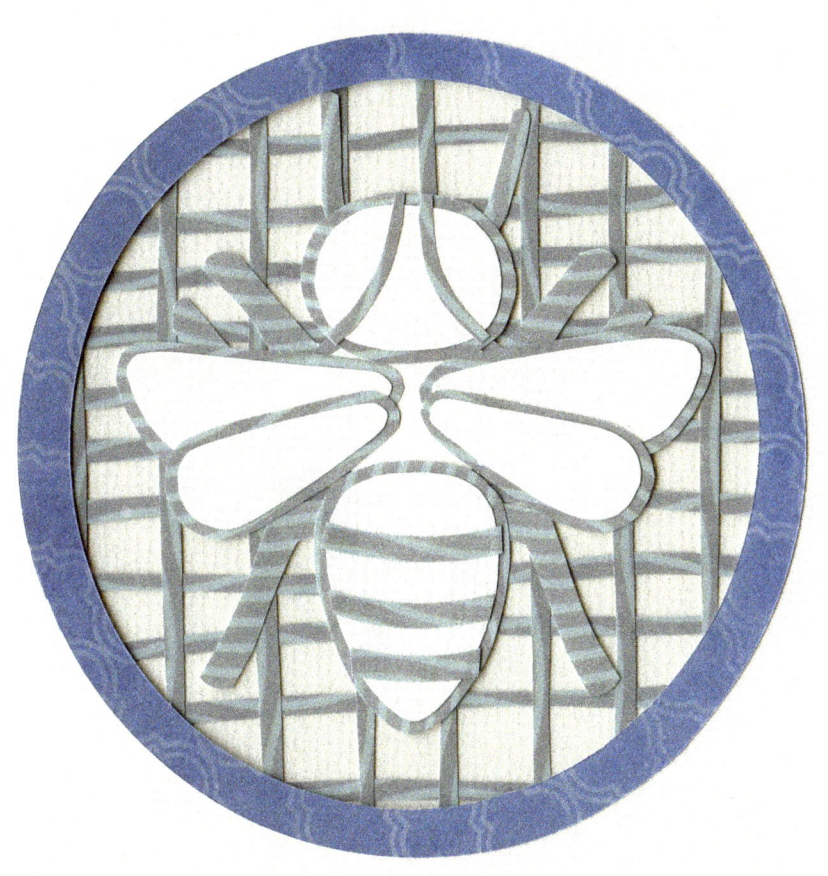

BEES, TRANSDISCIPLINARITY AND ARTS INTEGRATION

Integrating art into the curriculum means three things: 1) exploring how the knowledge we learn in school fits together (intersects, overlaps and combines); 2) using the arts as a lens on the world and a means of interpreting it in different, more personal ways; 3) playing with what we learn in school to invent new worlds and new ideas.

There is confusion about what art integration is. Is it interdisciplinary? Is it multidisciplinary? It seems to me that art integration is transdisciplinary. It also appears that the world of bees is an apt metaphor for transdisciplinarity.

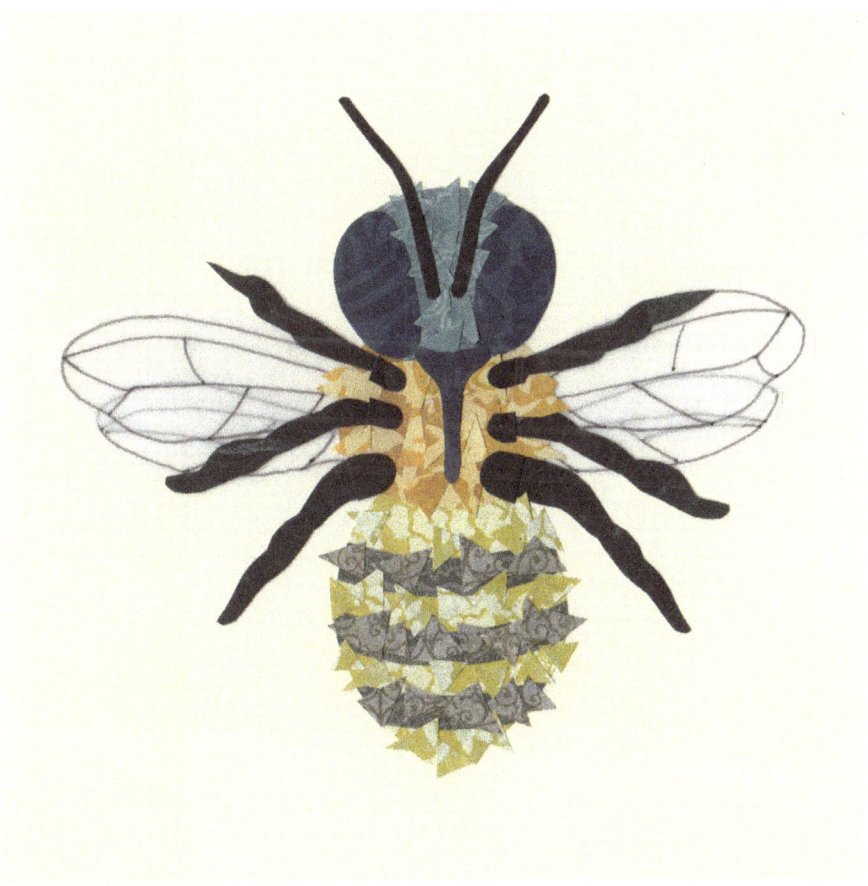

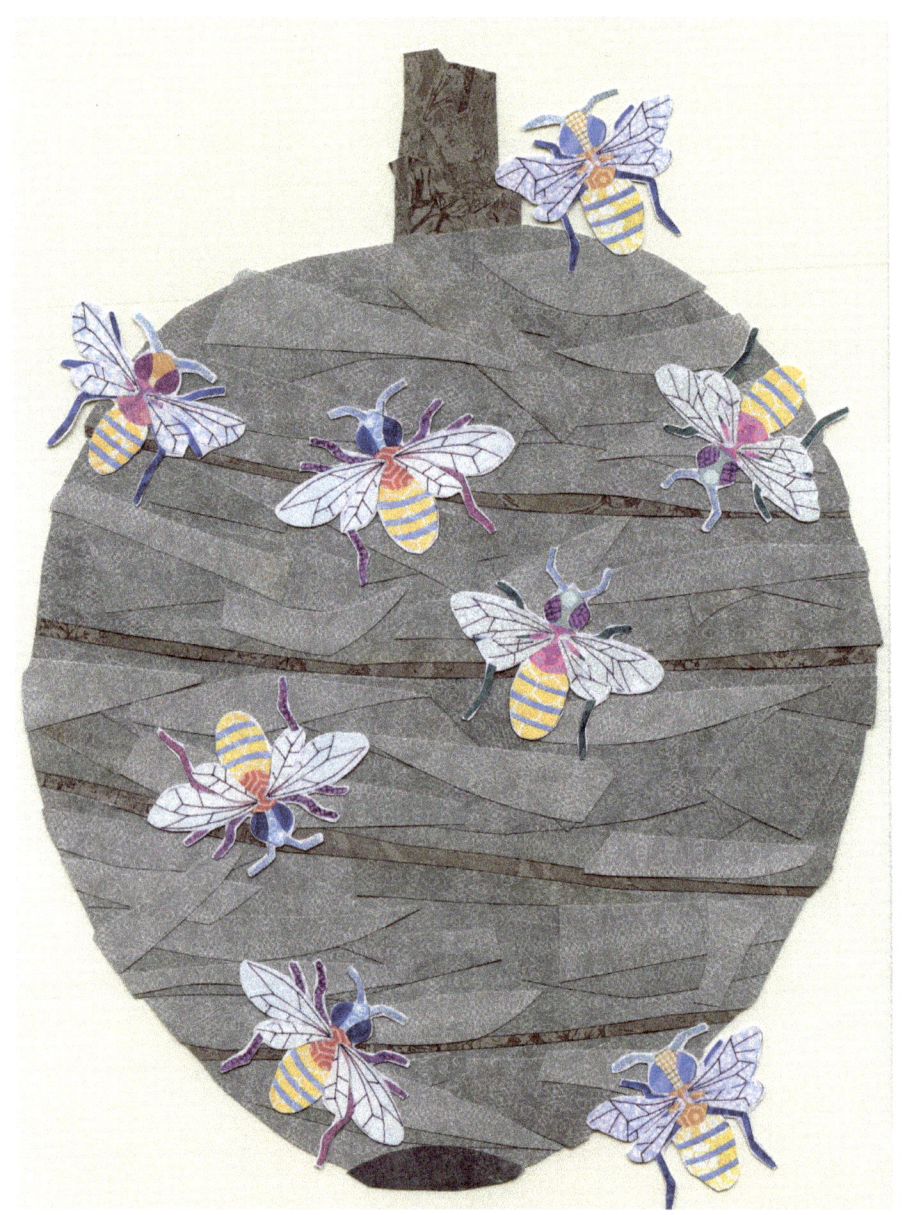

The Transdisciplinary Hive

Transdisciplinarity

What is transdisciplinarity? This term applies to a domain that has a very specific focus, which requires multiple ways of knowing, many ways of thinking, and many sources of knowledge. To explore its focus, a transdisciplinary domain must pull from a variety of different disciplines; it must transcend disciplines.

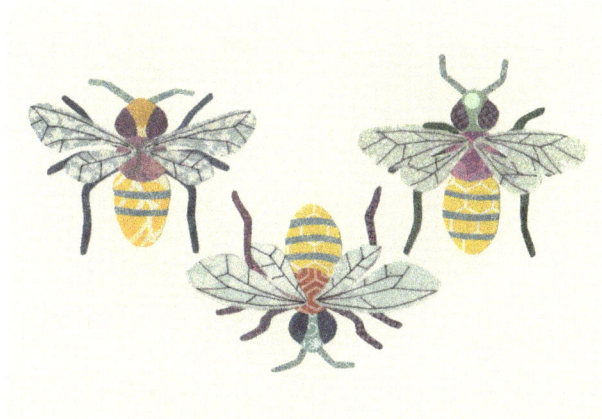

Transdisciplinarity connotes more than crossing disciplinary boundaries. It is a very specific kind of domain that has the following elements:

> One: It has a coherent conceptual framework, lens, or a meta-disciplinary perspective.
>
> Two: It works through a variety of interdisciplinary methods and practices. Practitioners work in hybridized, inventive ways.
>
> Three: It has a distinct epistemology—ways of knowing, doing research and the kinds of knowledge it constructs.
>
> Four: It honors and critiques its component disciplines.

The first three of the elements of transdisciplinarity are embodied in bees, in what they do and how they do it. To fully grasp how a hive of bees can represent transdisciplinary arts integration, we overlap the webs of understanding for each side of the metaphor,

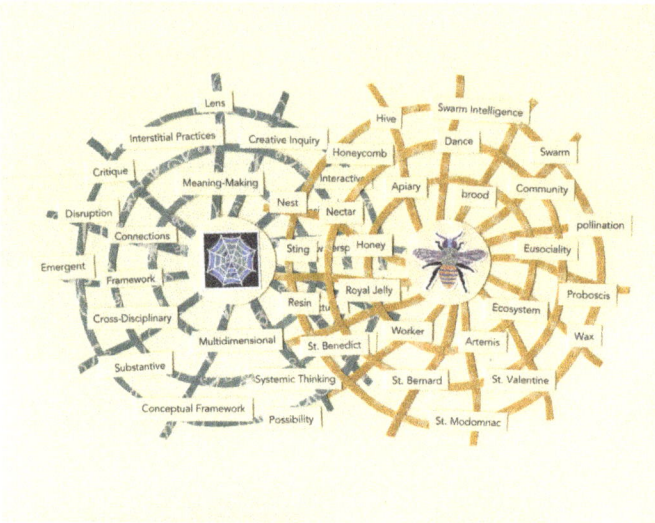

Webs of Understanding: Bees and Transdisciplinarity

fully realizing that the metaphor requires dual research, research Into both sides of the metaphor: Bees and Transdisciplinarity.

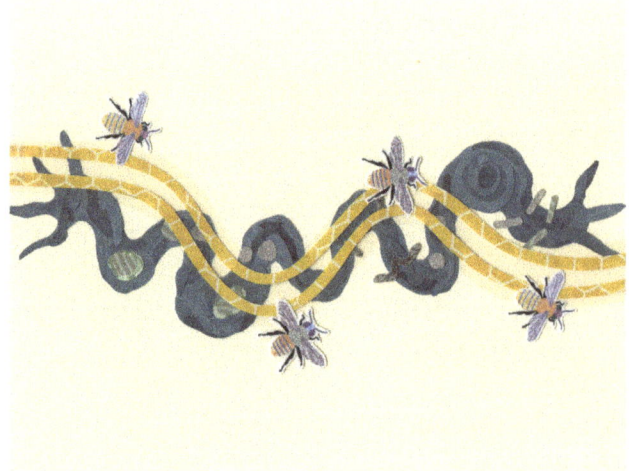

Bee and Integration Research

Framework/Structure

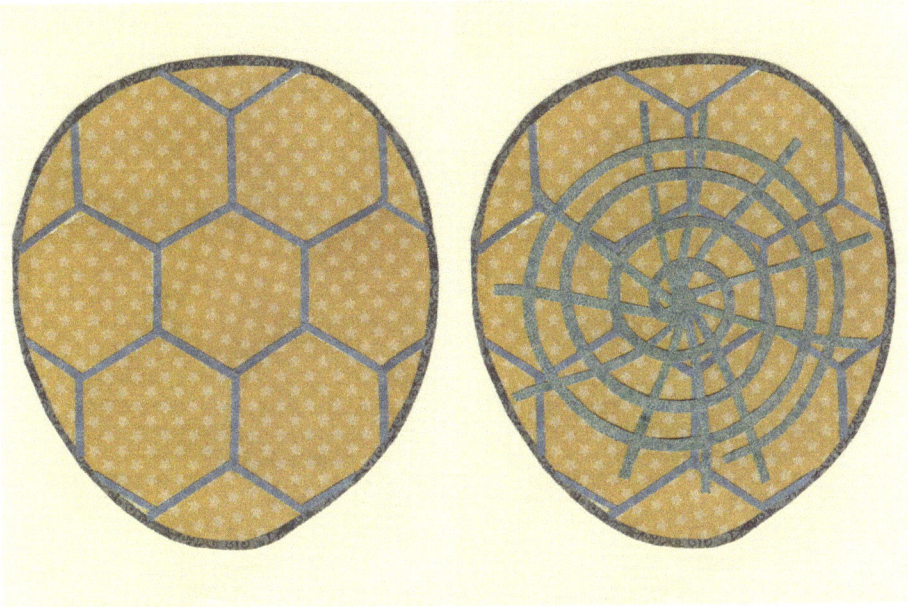

The Hive (left) and Interdisciplinary Structure (right)

Every transdisciplinary field has a philosphical home where practitioners "dwell" and work. This home is one aspect of a domain's structure. For Integration bees, it is a hive full of honeycombs.

Hives are intricate structures in which each compartment has a designated purpose. In a transdisciplinary field, structure is also the organization or relationships among component disciplines. Disciplines exist as separate yet permeable cubicles in the hive. Each component discipline contributes its distinct wisdom to the whole; each is an essential part of the system. Beehives represent how these domains are separate, yet connected and interactive. They show how the architecture of the hive supports a multidisciplinary and integrated system.

Vision

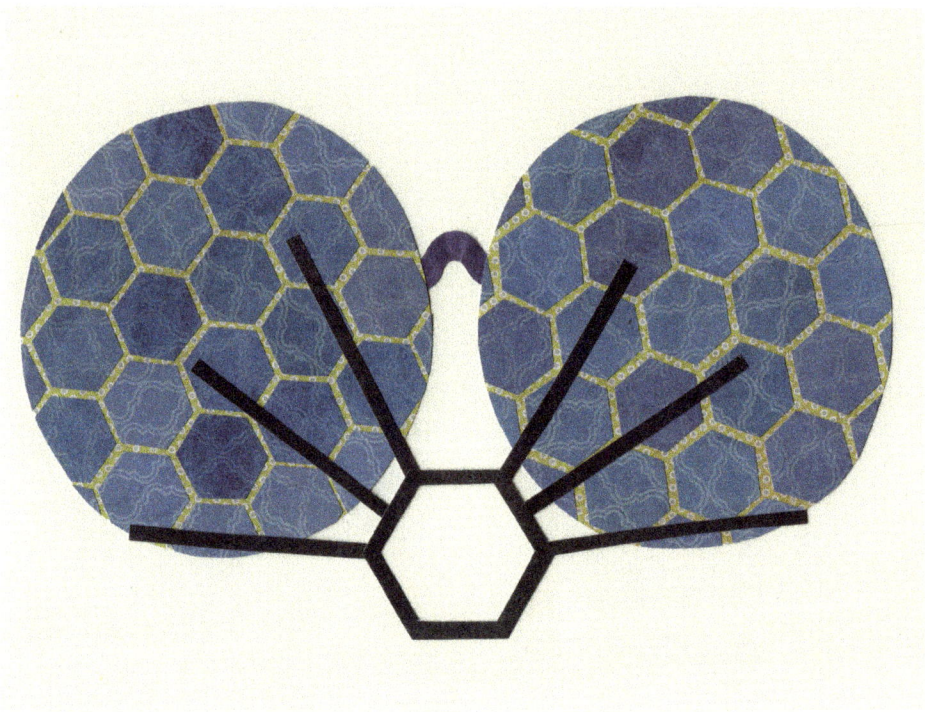

Conceptual Structure: Many Faceted but Focused Lens Structure also implies a focus or vision. A transdisciplinary field has a multifaceted view of the world; it places multiple, diverse kinds of knowledge within its holistic vision. This vision sets the conceptual framework that shapes every aspect of a transdisciplinary field; it is the lens through which the field perceives the world.

What is the conceptual lens of arts integration? In arts Integration, disciplines are viewed as part of a system of knowledge, and the focus for art integrators is on how learners understand the system and create new knowledge.

Arts integration uses art-based learning to promote complex, multifaceted understandings that involve seeing how things fit together, what's important about them, and how they connect to learners' lives. This is integration bee-vision.

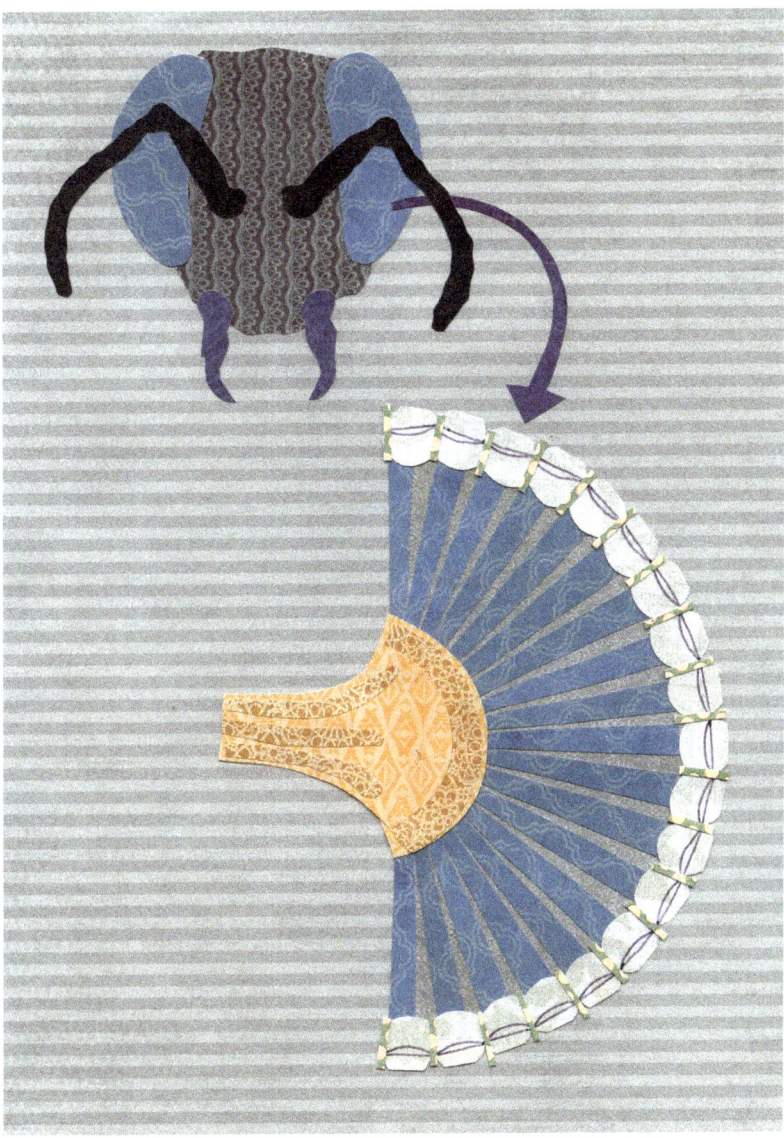

The Complex Faceted yet Focused Eyes of a Bee

Hybrid Practitioners

As artists, educators and researchers, integration bees are a hybrid species that live in multiple worlds: education and pedagogy, art and culture, learners and their worlds, and the art studio. These bees create and perform pedagogy that mixes the practices and purposes of art with the theories and methods of education. Learners are hybrids too: they are artists, researchers and scholars.

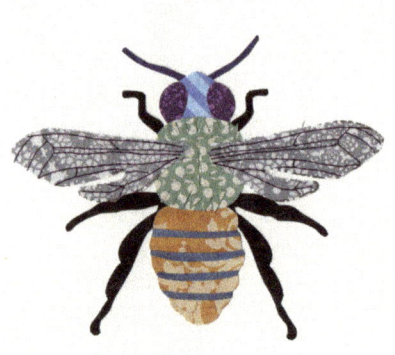

Artist Teacher

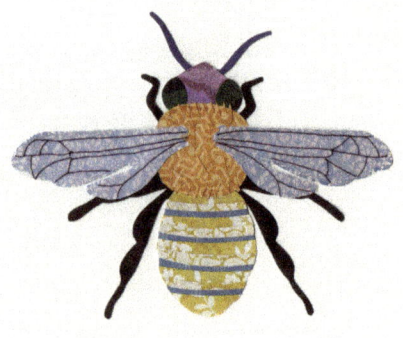

Artist Learner

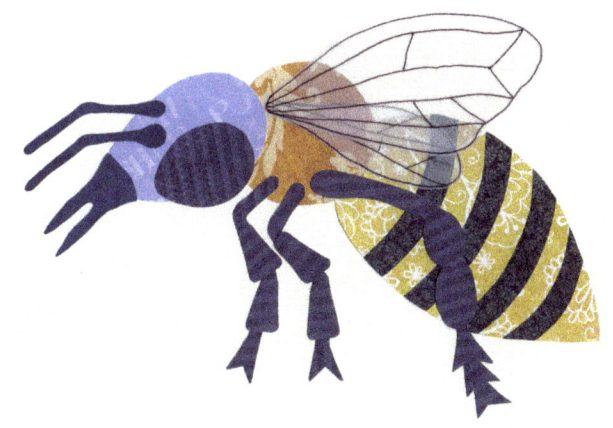

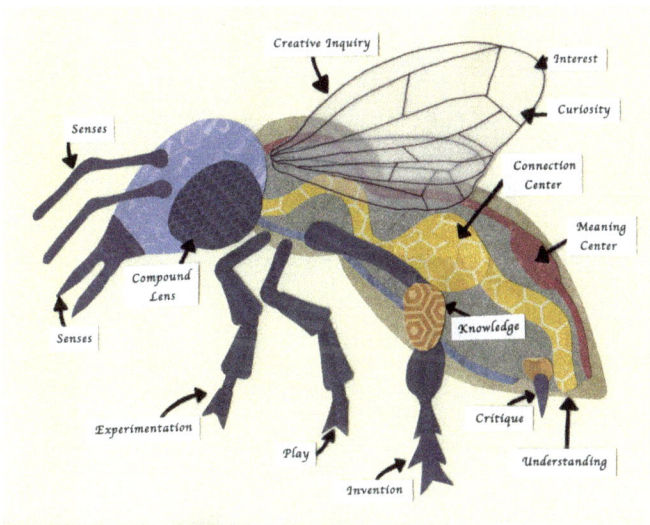

Anatomy of a Practitioner

Clues to the way integration bees do their inquiry are found in their anatomy. Each part has a different research function. The functions include: observe, digest, process, invent, play, experiment, critique and connect. Ultimately this inquiry produces knowledge and understanding. The process is set aloft by curiosity and interest—the wings.

Integration bees find inspiration and support for arts integration in contemporary artists who cross-disciplinary boundaries to explore transdisciplinary topics. These contemporary artists also practice art-based research.

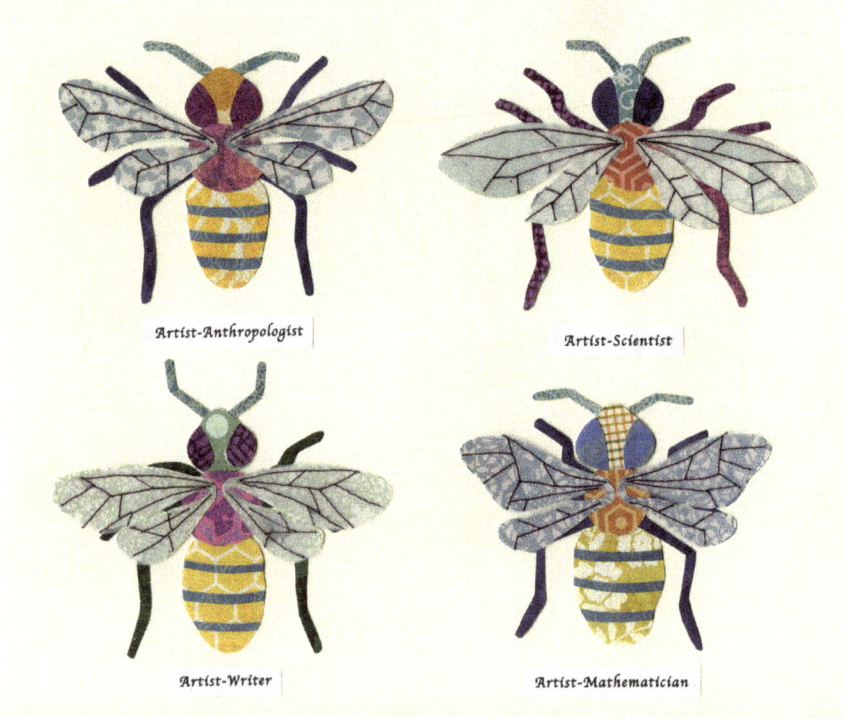

Hybrid Contemporary Artists

That means they gather information about a topic and employ the methods and forms of art to explore their topic further to make sense and meaning. As integrators, they also use methods from the sciences, math and humanities. In so doing, they construct new knowledge of their topic. This is creative integrated inquiry.

Epistemology and Knowledge

Epistemology refers to knowledge and how that knowledge is constructed. Integration bees make honey (knowledge). The honey they produce is both integrated and interstitial. It can mix in the combs (integrated)

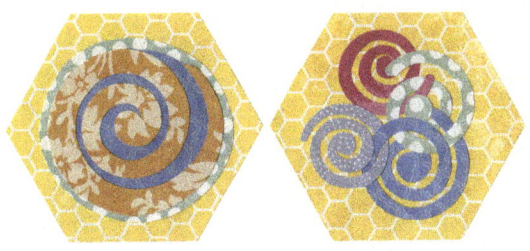

Integrated Knowledge

or spring up in the borders between combs (interstitial).

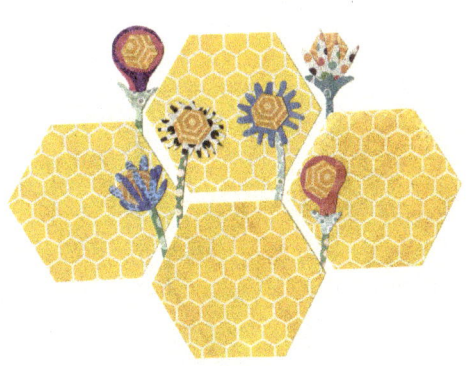

Interstitial Knowledge

Arts-integrated knowledge is serious, personal and meaningful. It is also playful and complex—often surprising and fresh.

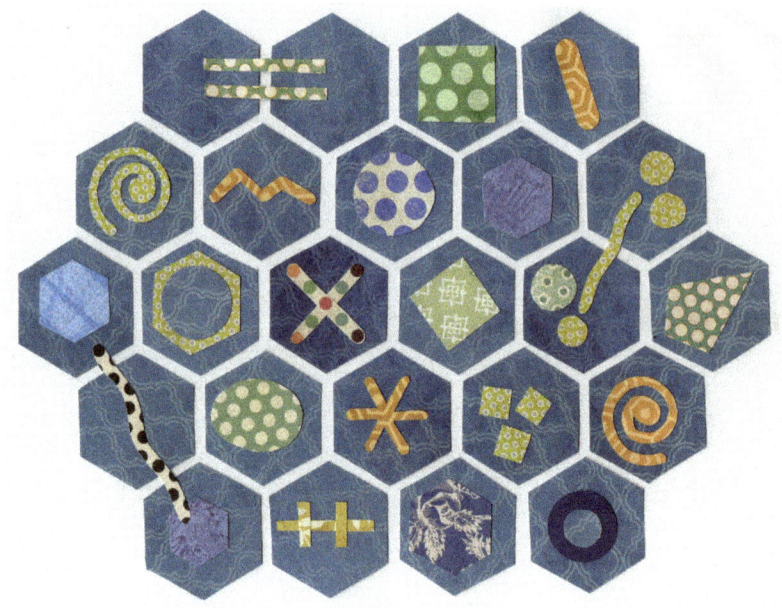

Playful Interpretations

Multiple Perspectives

Interstitial, Multi-Disciplinary Methods

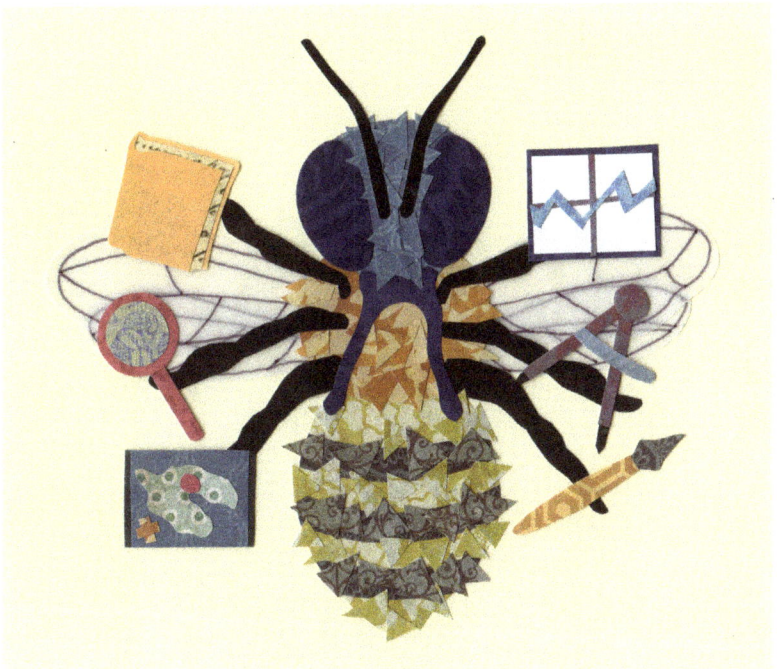

Shiva Bee: Hybrid Practices and Forms

Transdisciplinarity works in interstitial spaces--on the borders between disciplines. These spaces are where new practices emerge. These interstitial practices are hybrid methods that combine procedures of different disciplines or adaptive processes that apply methods of one discipline to another. The Shiva Bee above has been observed using tools and methods from the arts, the sciences, the humanities and education.

Arts integration, like any living discipline is always evolving, and adapting as circumstances change. The engine of this change is research. Research for bees is finding and harvesting nectar—source material—in various flowers. Each flower has its own flavor that it brings to the honey.

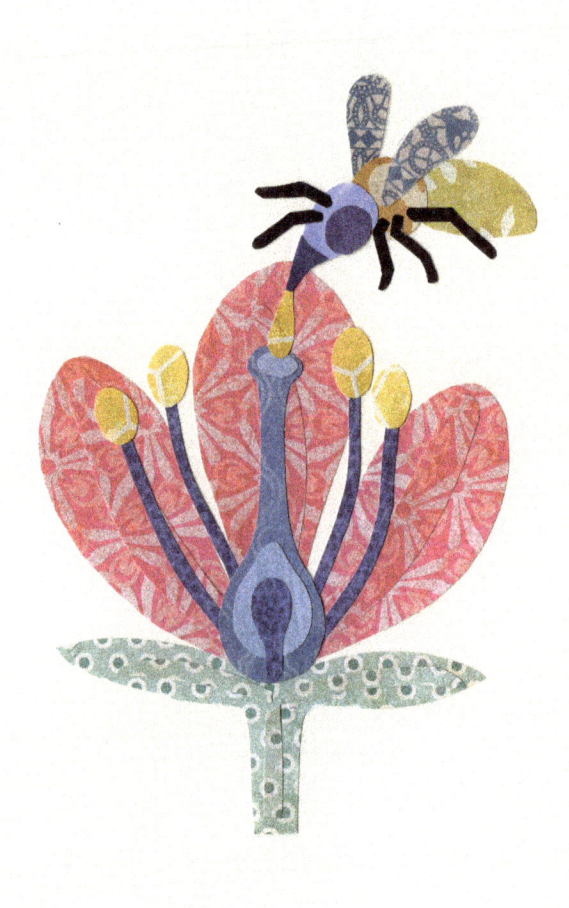

Research

Research is completed when the nectar is taken to the hive where it is turned into rich mélange of honey and stored in the proper honeycombs.

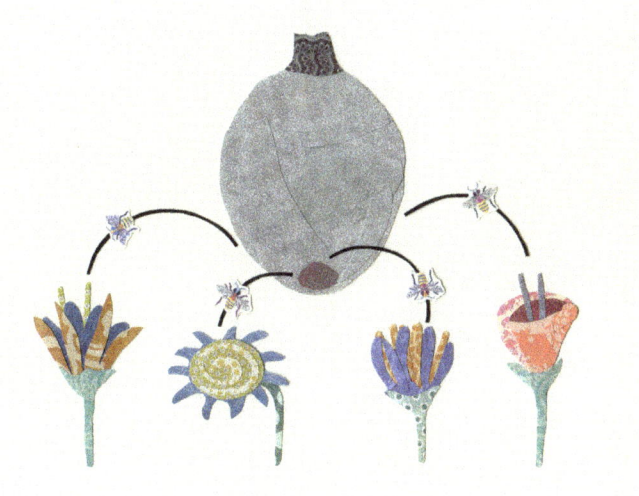

Research: Gathering Information and Ideas

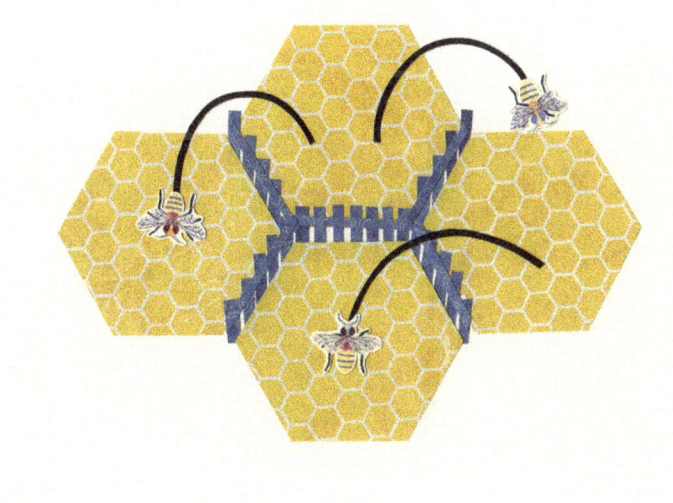

Research: Analyzing, Connecting, Integrating, Storing

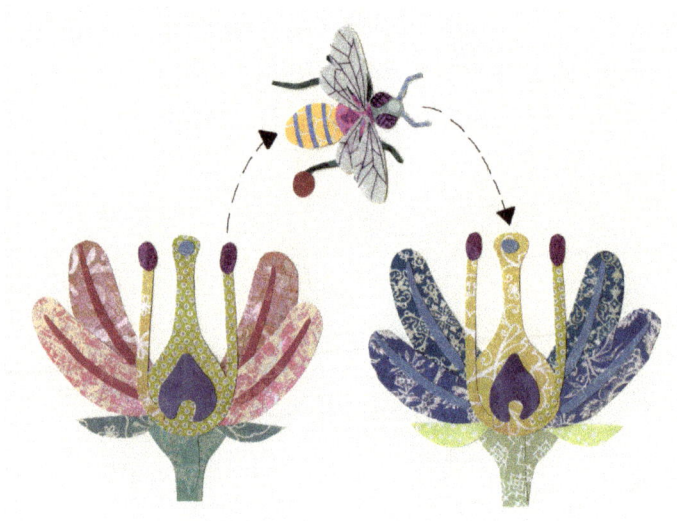

Pollinating Between Sources

The side effect of bee research is pollination. As the integration bees gather nectar, they carry pollen from one flower to another. New seeds are the result. This can lead to new varieties of flowers or changes in existing species—new ways of thinking, new perspectives, new disciplines.

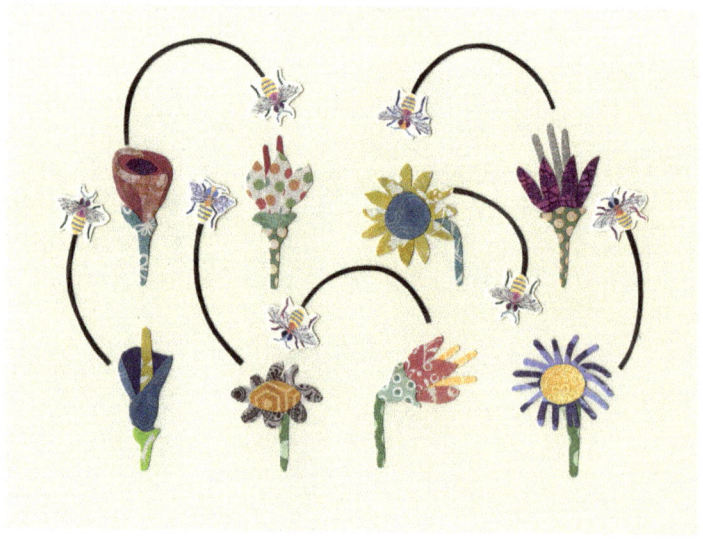

Cross Pollinating: Seeding New Things

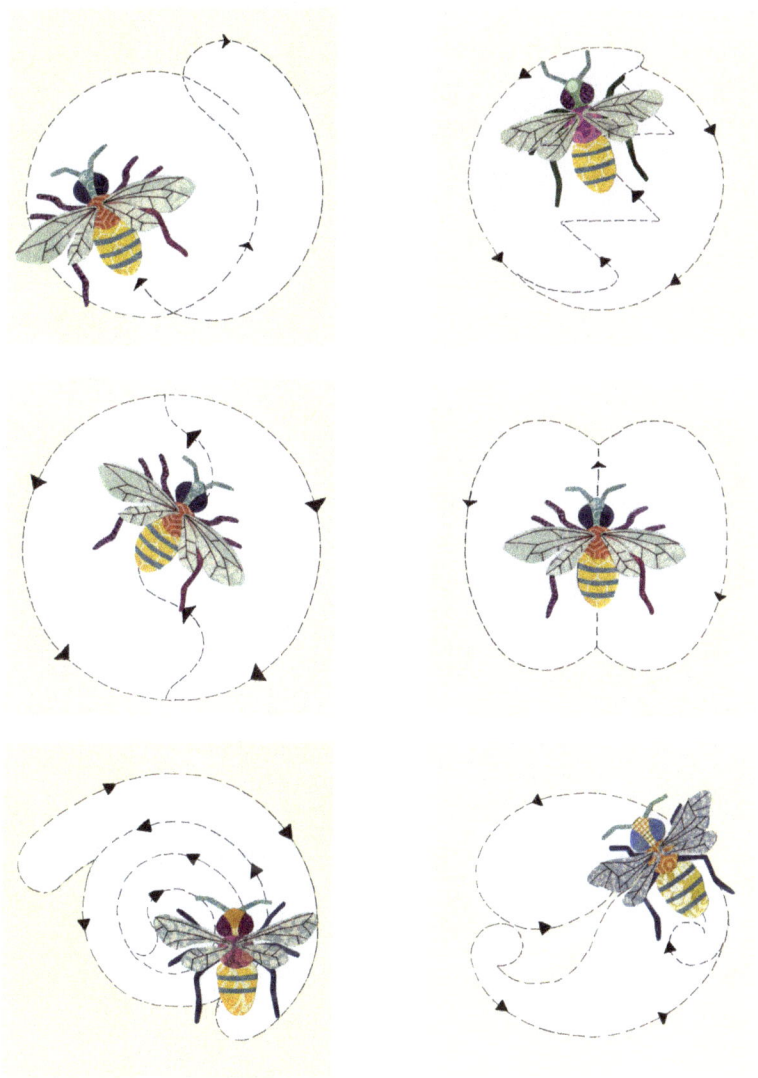

Performing Understandings

Another primary function of integration bees is to teach. Here we see the choreography of the bees—the way they engage learners through performing understandings and welcoming them to choreograph and perform their own.

Arts integration is an interstitial practice. Located between art and education, arts integration generates innovative arts-based pedagogies to counteract commonplace teaching and learning methods such as memorization, reading, drilling, expository writing and testing, which promote acquisition of information. Instead, art integration fosters understanding and uses strategies such as translating concepts and information into visual form or creating something new from what students are learning in school. Most importantly, arts integration encourages creative inquiry to engage students in personal meaning-making. This is creativity for understanding.

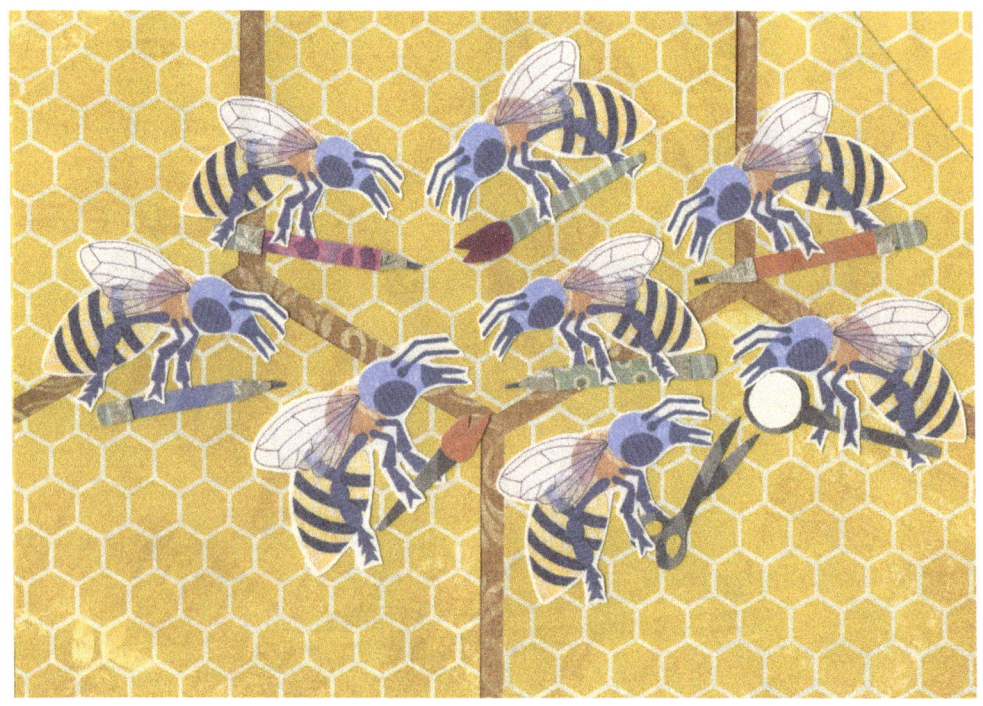

Multiple, Creative Ways of Inquiry and Learning

Arts Integration is an innovative and valuable way to engage young people in meaningful, holistic learning. When it entails creative inquiry, arts integration draws on and validates the interests of learners. It also gives them the freedom to play with ideas and information through artistic forms and methods. It enables them to see connections and what is important to them and the world.

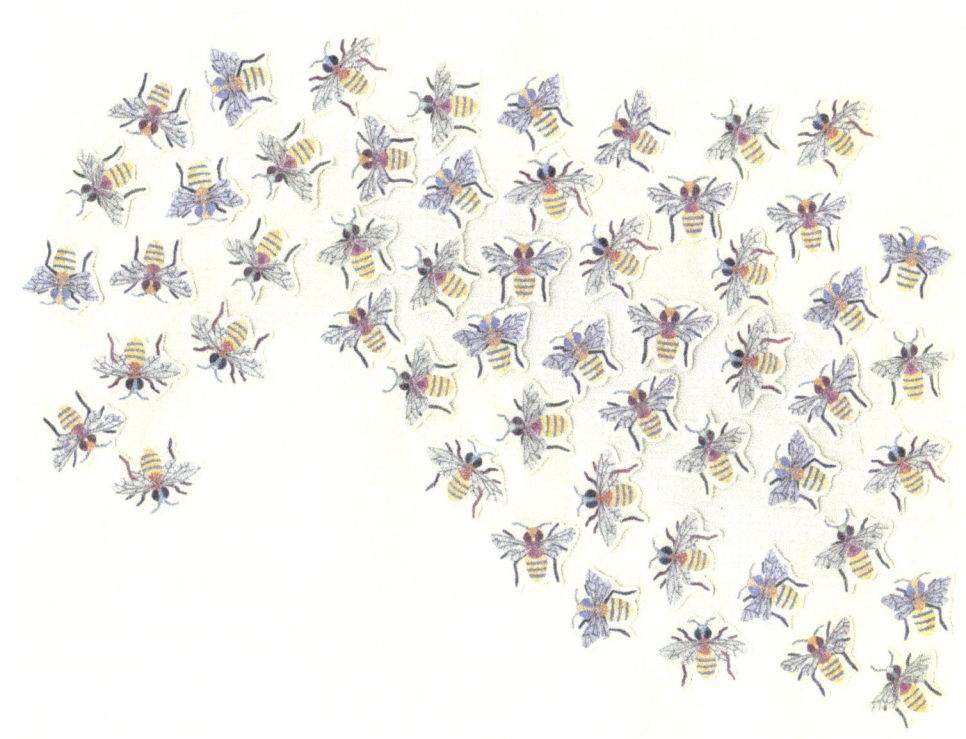

Swarm Intelligence

Arts integration bees are learners, teachers and artists. They are a community of innovators who are changing the way kids learn and educators teach. Together they form a swarm and together their understandings and creativity generate the profound, uncanny wisdom of bees: Swarm Intelligence.

Part 3: Conclusion

PASSAGE TO NEW INQUIRIES

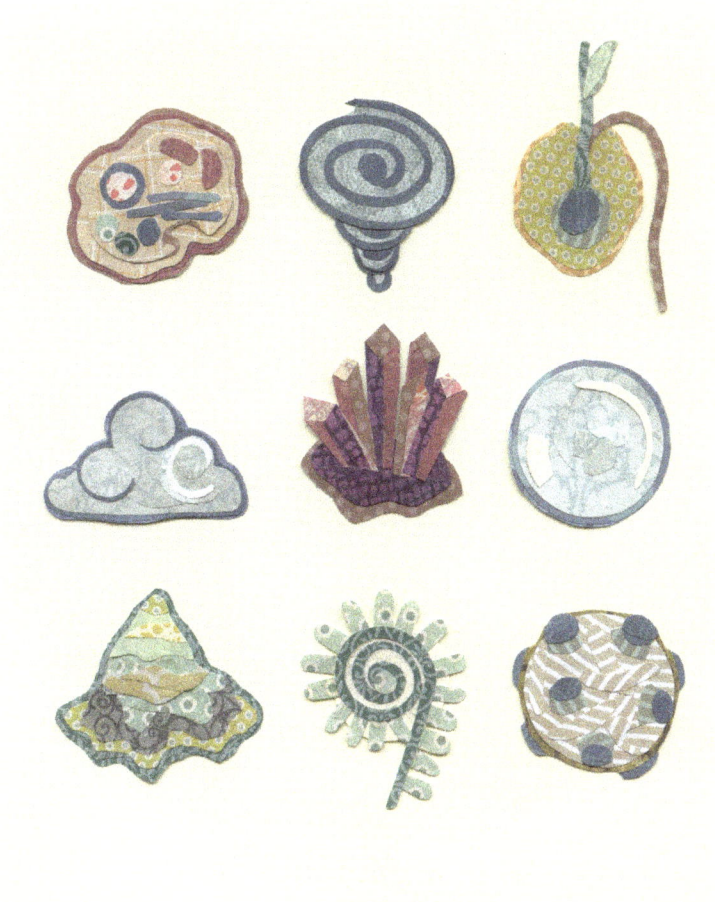

Just as water flows from the river into the sea, a lake or another river, creative inquiry does not stop. Just as corals grow and develop, learning continues to emerge and evolve. My conclusion here, therefore, is not the end of an inquiry but a passage to a new one. Above is a collection of metaphors from nature to follow in future explorations. The questions arise: What could they stand for and where could they lead?

References

CONSTRUCTIVISM AND SOCIAL CONSTRUCTIVISM

Bandura, A. (1977). *Social learning theory.* New York, NY: General Learning Press.

Berger, P. & Luckmann, T. (1966). *The social construction of reality.* New York: Anchor Books.

Fosnot, C. (2005). *Constructivism: Theory, perspectives and practice.* New York, NY: Teachers College Press

Lave, J. & Wenger, E. (1991). *Situated learning: Legitimate peripheral participation: Learning in doing: Social, cognitive and computational perspectives.* Cambridge, UK: Cambridge University.

Maturana, H. & Varela, F. (1980). *Autopiesis and cognition. The Realization of the living.* Dordrecht, Holland: Reidel.

Perkins, D. (1988). *Art as understanding.* In H. Gardner & D. Perkins (Eds.) *Art, mind & education: Research from project zero* (pp. 111-131). Chicago, IL: University of Chicago Press.

Piaget, J. (1952). *The origins of intelligence in children.* New York: International University Press.

Vygotsky, L. (1978). *Mind in Society.* Cambridge, MA: Harvard.

TRANDISCIPLINARITY

Klein, J. (2000). Voices of Royamount. In M. Somerville & D. Rapport (Eds.), *"Transdisciplinarity" Recreating integrated knowledge* (pp. 3-13). Oxford, GB: EOLSS.

Moran, J. (2002). *Interdisciplinarity.* London, UK: Routledge.

Rolling, J. (2013). *Swarm Intelligence: What nature tells us about shaping creative leadership.* New York: Palgrave MacmIllan

Trueit, D. (2005). *Watercourses from Poetic to Poietic.* In C. Doll, M. Fleener, D. Trueit & J. St. Julien. *Chaos, complexity, curriculum and culture.* New York: Lang.

CPSIA information can be obtained
at www.ICGtesting.com
Printed in the USA
LVHW070915230723
753178LV00055B/977